IMAGES
of America

AROUND
MURPHYS

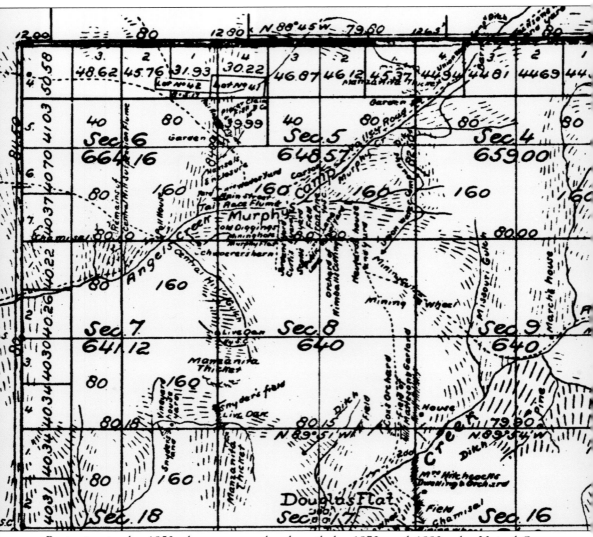

Beginning in the 1850s, but not completed until the 1870s and 1880s, the United States General Land Office mapped all of California into townships, ranges, and sections based upon the Mount Diablo Base Meridian in Central California. Surveyed in 1874, Murphys Camp was located in the Southwest Quarter of Section 14, Township 3 North, Range 14 East, MDBM. The surveyor also noted Angels, Murphys, and Coyote Creeks, the Carson Valley Road, Union Water Company Ditch, Main Street, Murphys Flat, Old Diggings, hard rock mines, dwellings, orchards, yards, barns, gardens, fields, fences, and other natural and cultural features.

IMAGES
of America

AROUND
MURPHYS

Judith Marvin

ARCADIA
PUBLISHING

Published by Arcadia Publishing
Charleston SC, Chicago IL, Portsmouth NH, San Francisco CA

Printed in the United States of America

Library of Congress Catalog Card Number: 2005924556

For all general information contact Arcadia Publishing at:
Telephone 843-853-2070
Fax 843-853-0044
E-mail sales@arcadiapublishing.com
For customer service and orders:
Toll-Free 1-888-313-2665

Visit us on the Internet at www.arcadiapublishing.com

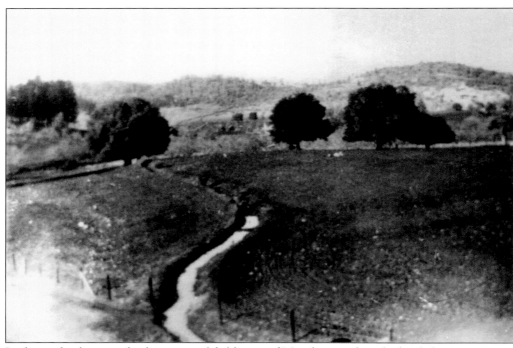

In this early photograph, the primeval fields east of Murphys are disturbed only by an irrigation ditch and fence. The mature valley oaks still held sway over lands now dotted with houses, and the hillsides were covered only with chaparral.

CONTENTS

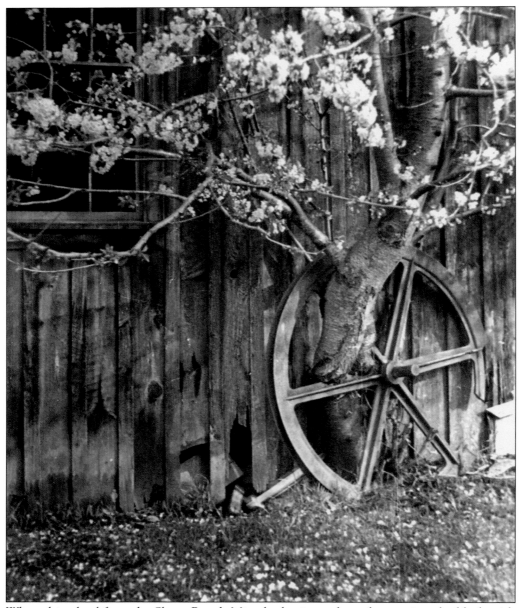

When this wheel from the Sheep Ranch Mine broke, it was leaned up against the blacksmith shop, where the smith made a new one. Years later, a prune plum grew through its spokes. Today, only the wheel and tree remain.

INTRODUCTION

The withered body of history is lifeless without the soul of today.

—Tibetan scholar

It has been over 50 years since the last history of Murphys was written: Coke Wood's *Murphys, Queen of the Sierra* (1952). While Wood's book presented a history of many of the historic events, persons, sites, and annals in the early history of Murphys, recent trends in historical research have focused on the context or themes of history, and this publication attempts to present the narrative of this community within the broader context of those themes. It was also determined to bring the history of Murphys up to the present time, rather than freezing it in the late 1800s. All of the contexts, or themes, that were important during the early years of the Gold Rush are present today: Native Americans, mining, transportation, water, community, agriculture, ethnicity, tourism, and development.

This publication is designed to serve as a guide to the historical and prehistorical resources of the community. After the publication of Coke Wood's history, and also that of Ken and Doris Castro in 1972, the Calaveras County Archives was established, making available to the public the deed books, assessment rolls, homestead and land claim books, mining claim books, and other archival materials not available to the original researchers. Therefore, much of the information on the history, as well as the cultural and architectural resources, has been compiled from these primary sources and is presented here to augment the information in those earlier publications.

Much of the research on individual buildings was conducted in 1981, for a National Register of Historic Places nomination for Murphys. The nomination was approved by the State Historic Resources Commission at a meeting in Murphys that year, but was denied in Washington because of the infill of modern buildings within the proposed historic district.

Other primary sources of information include the cards, notes, files, and maps of the late Frances Bishop of Arnold, an indefatigable researcher on the early history of Calaveras County, especially Murphys, the Big Trees, sawmills, roads, ditch systems, and other topics covered in this publication. Of great help also were the unpublished archaeological and historical studies conducted for the California Department of Transportation, the U.S. Forest Service, PG&E, the Army Corps of Engineers, California Department of Parks and Recreation, Calaveras County Planning Department, and private individuals, on which the author worked with colleagues

Julia Costello, Shelly Davis-King, and others. It is important that this "gray literature" be exposed to the light.

Images for this publication were scanned from the collections of the Old Timers Museum, Murphys; Calaveras County Archives and Calaveras County Historical Society, San Andreas; the Oakland Museum of California, Oakland; the files of the author, Murphys; and from private collections as noted.

The author is overwhelmingly grateful to Wally Motloch, who uncomplainingly carried his scanning equipment from repository to repository, then spent many hours in producing the final images. Many thanks also to Terry L. Brejla, who edited the document, and Willard P. Fuller Jr., who reviewed it for content and authored the chapter on geology. David and Jo Ellen Gano, local schoolteachers, also reviewed it for readability and use in the local schools.

One

HOW IT ALL BEGAN

The geologic history of the Murphys region begins some 300 million years ago in what geologists call the Paleozoic Era. Here was a shallow sea with prominent coral reef islands. In the far distance one might see large mountain ranges. Over the millennia, geologic erosion was wearing down these mountains, washing great quantities of sand and silt into the shallow sea, covering up the coralline islands with sediments thousands of feet thick. Then, some 135 million years ago, as time passed into the Mesozoic Era, great geologic forces began to act upon these sediments, generated by the movement of tectonic plates. Faulting, crushing, and other deformation caused by the extreme pressures and temperatures created a massive, high-standing mountain range, the ancestor of today's Sierra Nevada.

The thick sedimentary rocks were metamorphosed (recrystallized) into slates, schists, and quartzites, and the coral reefs into marble. Today, some of these rocks can be seen well exposed in the roadcuts below town on the "grade road." The white marbleized reefs outcrop throughout the region, to the north and south and right in town. Above town along Highway 4 are slates and schists even older than the marbleized coral reefs. (Courtesy of the author.)

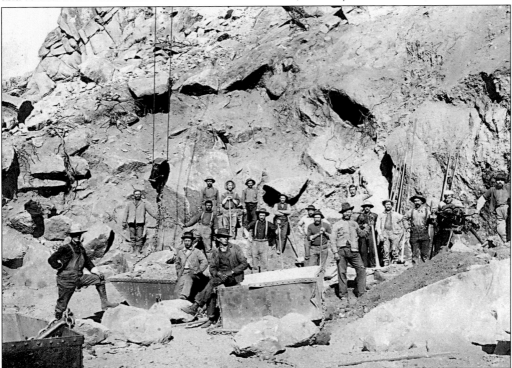

Accompanying the geologic deformation described above were hot mineralizing solutions that created gold-bearing quartz veins such as those at Oro y Plata Mine, just north of town below Mi-Wuk Rancheria, and many other veins throughout the general Mother Lode region. (Courtesy of Murphys Old Timers Museum.)

For the rest of the Mesozoic Era, some 65 or more million years, the rugged peaks of the ancestral Sierra were worn down by intense geologic erosion to a mature landscape gently sloping westward to the Western Ocean. A thickness of more than 10,000 feet of rock had been removed from the vicinity of Murphys by this long period of degradation, and the debris washed down into the Great Valley. In this process, the quartz veins were ground up, and the gold was liberated from the tight grip of the quartz. The pieces of gold, much heavier than the quartz and other mineral material, were gradually transported downstream, the larger pieces or nuggets moving a relatively short distance, and the finer gold traveling much farther down. Most of the gold worked down through the sand and gravel of the streambeds to form placer deposits on or just above the bedrock. One of these gold-bearing stream channels flowed into the Murphys region and then swung down to Douglas Flat and thence westerly towards Angels Camp. (Courtesy of the author.)

About 65 million years or so ago, with the beginning of the Tertiary period, the Sierra Nevada mountain clock slowly began to rise, causing more silt, sand and gravel to be eroded and washed on downstream, covering up the gold placer deposits in the old stream channels. Many volcanoes, east of the present crestline, spewed out enormous amounts of volcanic ash, mudflows, and lava onto the western flank of the range, along with other debris. Repeated uplifts of the crest created new westward flowing streams that cut deeper into the old landscape, often slicing into the older placer deposits, robbing them of their gold and forming second generation placers. By the end of Tertiary time, just a few million years ago, the western foothill region was a relatively smooth, mostly sand and gravel-coated surface sloping gently down to the Great Valley. There was still the rock ridge north and west of town, as well as other bedrock ridges standing above the gravelly landscape. (Courtesy of the author.)

11

A series of strong and repeated uplifts raised the Sierran crest to heights greater than today's elevation. New river channels rapidly formed and began excavating the great canyons of the Stanislaus and Mokelumne Rivers. Sharp ravines cut back from these canyons by headward erosion up into the range, forming such drainages as those of Coyote Creek and Angels Creek. (Courtesy of the author.)

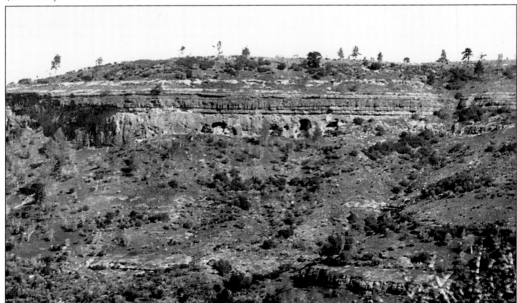

Much of the soft, flat-lying Tertiary sedimentary beds were removed, leaving long prominent flat-topped ridges north and south of Coyote Creek where today can be seen these formations of volcanic debris in white to gray-brown cliffs. The ridge between Coyote Creek and the Stanislaus River is capped by a hard lava flow, called the Table Mountain latite. The geologic history concludes with some minor faulting with further erosional changes to shape today's landscape. (Courtesy of the author.)

Two

FIRST INHABITANTS

Although humans were present in Calaveras County as long as 14,000 years ago, abundant evidence exists for more recent native populations of the last 2,000 to 3,000 years. The earliest known occupants of this area, identified by the presence of distinctive projectile points found on local sites, were members of Great Basin tribes. Somewhere between 1,000 and 500 years ago, the Northern Mi-Wuk arrived in the area, often settling on sites occupied by their predecessors, and following the same pattern of wintering in the foothills and following the game and food sources into the Sierra Nevada during the summer months. It was the Mi-Wuk who intensified use of the acorn as a staple food and utilized milling stations with multiple grinding holes. With the discovery of gold in 1848, the land was quickly overrun by gold seekers who appropriated both the water and the land of the Mi-Wuk. Game virtually disappeared and most Mi-Wuk were forced out of their favorable village locations for more remote sites. The native population was also decimated by introduced diseases and loss of food resources such as deer and acorns.

Driven from their pre–Gold Rush occupation sites in Murphys, situated where there was abundant water from creeks and springs, many families established their homesites along the Union Water Company's ditch above town, on the Williams Ranch, Oro y Plata Mine, and on the ranches of Euro-American farmers, for whom they labored. The men generally worked as field laborers, fence builders, cowboys, and in the timber industry, while the women washed clothes and tended the children of the Euro-American families.

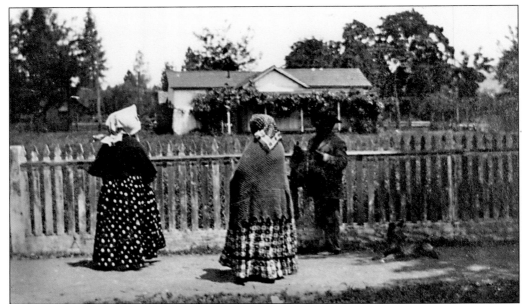

Beginning in the 1890s, several ethnographers visited the area, recording the language and lifeways of the surviving members of the tribe. Townspeople also began to take an interest in the few remaining Mi-Wuk people, and their photographs record the contrast between the indigenous and modern lifestyles of the day. In this photo, two Mi-Wuk women dressed in the style of the times talk with Captain Yellowjacket in front of a house on Main Street. (Courtesy of the Calaveras County Historical Society.)

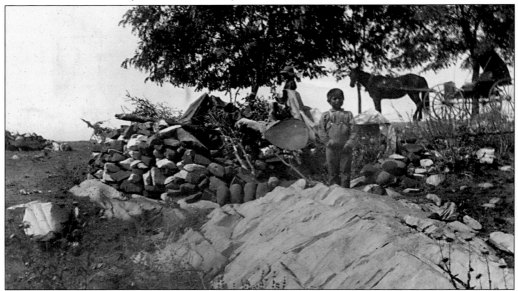

Four different rancherias were located around Murphys in historic times, but the most important was located on the rocky ridgetop above the Oro y Plata Mine on Sheep Ranch Road north of Murphys, occupied intermittently from 1870 to 1912. In 1906, a young boy was photographed near a rocky outcrop, with the photographer's horse and buggy in the background. (Courtesy of the author.)

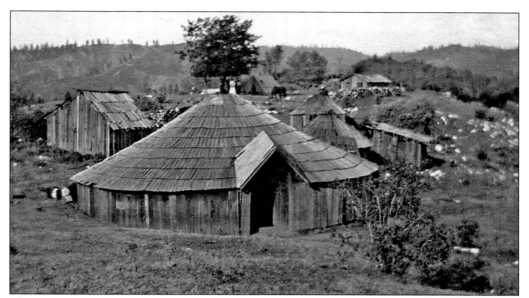

The structures at the rancheria consisted of a roundhouse, three conical dwellings, three gable-roofed cabins, and two shacks. The roundhouse, which served as a center for village ceremonies, storytelling, and other social events, was constructed in 1901 of fir from a local sawmill and cedar shakes from a mill at Big Trees. It measured 50 feet in diameter and had a firepit in the center, surrounded by four posts. The entrance was located to the southwest and a foot drum in the rear, while the dirt floor was covered with pine needles and benches were placed around the sides. (Courtesy of the Calaveras County Historical Society.)

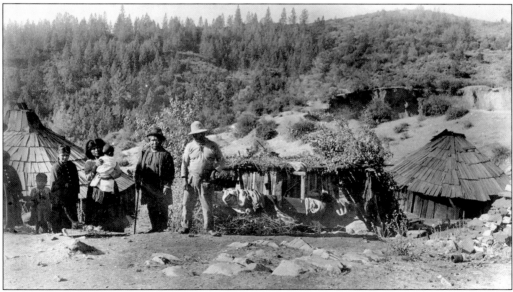

Those who resided on the site included the family of Sam Casoose (Jesus) and Lizzy Yaki Domingo and their 10 children. Sam hauled wood for various ranches, fished for salmon in the Stanislaus River, planted grain in a flat above the roundhouse, and raised potatoes, beans, and tomatoes. In 1900, the Domingo family was photographed with Captain Yellowjacket. (Courtesy of the Calaveras County Archives.)

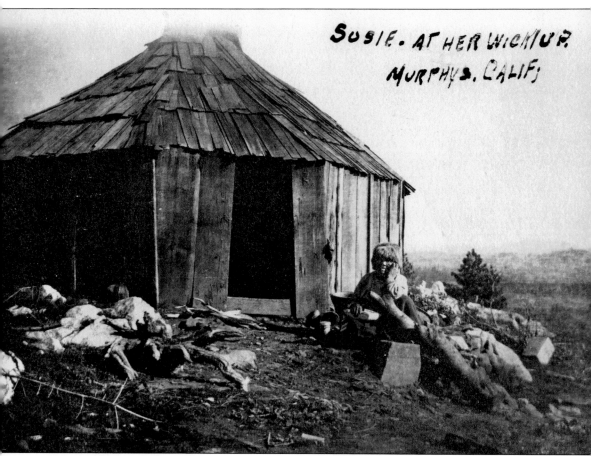

SUSIE. AT HER WICKIUP. MURPHYS. CALIF;

Others who lived on the ridgetop included Big Boot Jack and Sally, Captain Yellowjacket, Lucy, Chuella, Susie, and occasional visitors who lived at the small encampment. Susie is shown at her conical dwelling about 1901. (Courtesy of the Calaveras County Historical Society.)

Captain Yellowjacket was the blind leader of the rancheria and respected by others who visited there during "Big Times." He welcomed the morning sun in a sonorous voice from a high point of ground each day, and made speeches from a large rock during ceremonies. (Courtesy of the Calaveras County Archives.)

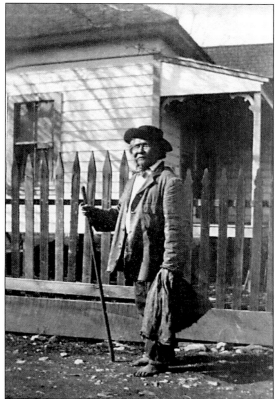

Pictured are Nora Domingo Crosby and her daughter at the Domingo dwelling on the Murphys Rancheria. In contrast to the conical buildings, this 1898 residence was constructed in the typical American style. (Courtesy of the Calaveras County Historical Society.)

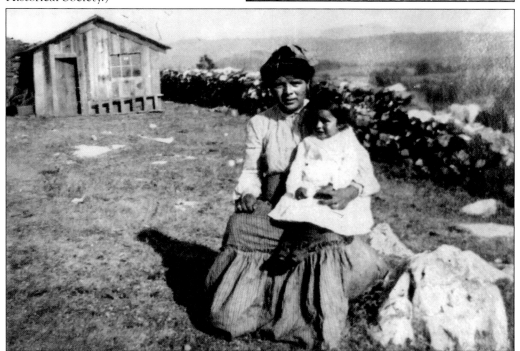

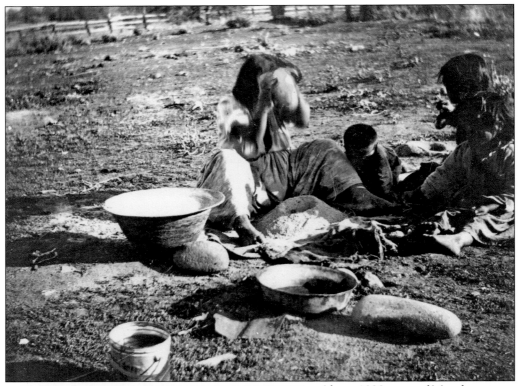

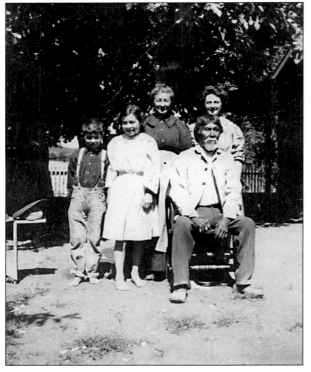

About 1898, west of Murphys at the Six Mile Rancheria, a woman was photographed pounding acorns. Note the stone mortars and traditional basket filled with acorn meal, as well as the modern lard tin in the foreground. (Courtesy of the Calaveras County Archives.)

Indian Walker, who resided at various places around Murphys and Vallecito, lived from the Stone Age to the Space Age. He even recalled seeing Kit Carson and John C. Frémont coming through the area during Frémont's second expedition in 1844. In later years, he was photographed in Douglas Flat with Mary and Rose Malatesta, and Lillian and Clarence Eltringham. (Courtesy of the Calaveras County Historical Society.)

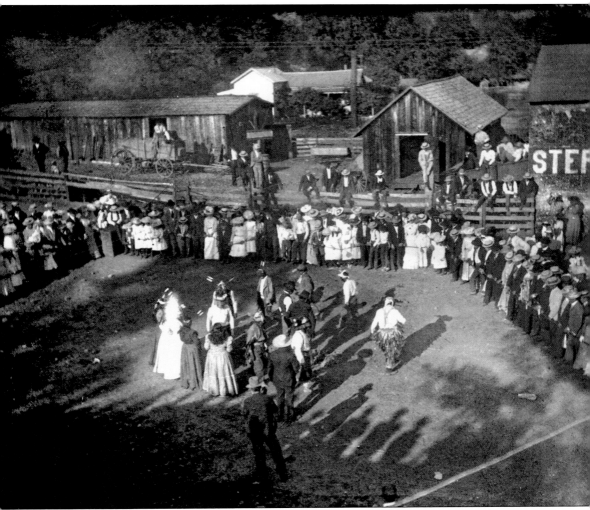

This Indian dance, or "fandango" as it was called at the time, was held about 1900 in downtown Murphys. Murphys was the site of one of the major meeting areas for the Mi-Wuk and the Washoe and Paiute tribes from Nevada, who traversed the Sierra Nevada in the fall of the year to trade pine nuts, obsidian, baskets, and other materials for acorns, berries, and other items. The event is still celebrated at Big Times in Amador, Calaveras, and Tuolumne counties in September of each year. This dance site was located on the northwest corner of Main and Center (now Algiers) Streets, where the Murphys General Store was later located. Note the "ST" of the Stephens Bros. Store sign on the brick and stone building to the right of the photograph, and the actual home of Albert Michelson to the rear. (Courtesy of the Calaveras County Archives.)

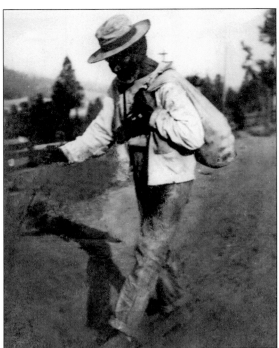

One of the earliest Native American settlements in the Murphys area was at the Adams Ranch on Pennsylvania Gulch Road, which has been occupied for over 10,000 years. "Old Nashua," a Mi-Wuk , was one of the last of his line to reside on the site. (Courtesy of Murphys Old Timers Museum.)

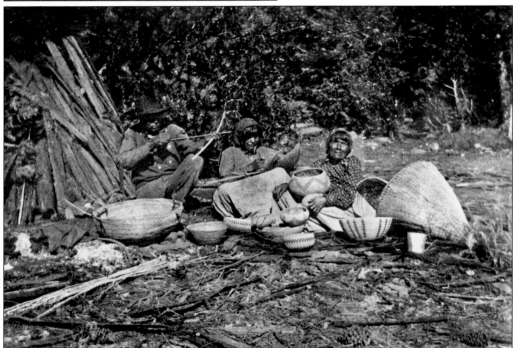

A Washoe family whose home was near Dorrington for many years, Suzie Arnott, her husband Joe, and mother Sally, made and sold beautiful baskets to tourists and townspeople, and gave basketry and arrow-making demonstrations at the Big Trees Hotel until about 1935. (Courtesy of the Calaveras County Historical Society.)

About 1900, Rose Davis, also known as "Limpy," was photographed at her home in Sheep Ranch. Note the shortened leg and the crutch, common among Indians in that time period. (Courtesy of the Calaveras County Historical Society.)

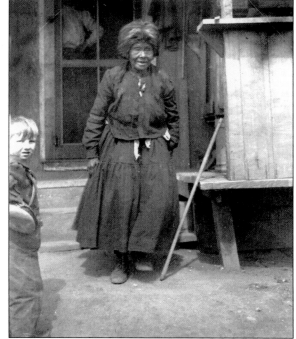

Joseph Noah Shrum and his wife, Emma Hunter, posed for the photographer about 1900 with their children Clara, George Henry, George Albert, and baby James Edward. (Courtesy of the Calaveras County Archives.)

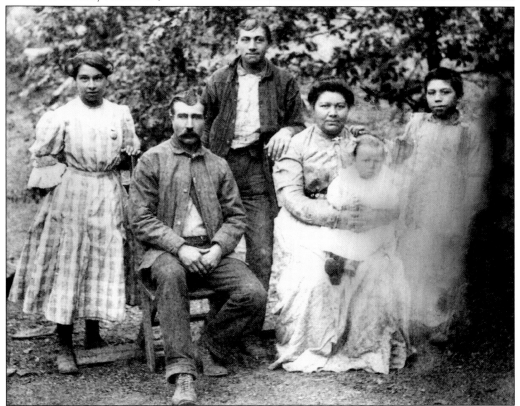

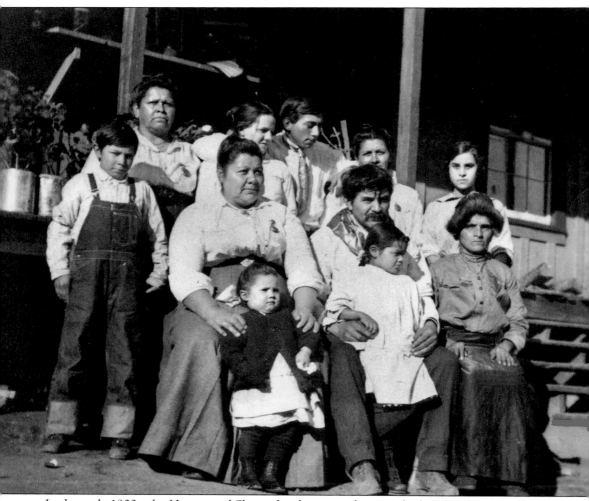

In the early 1900s, the Hunter and Shrum families were photographed at their home at Hunter Reservoir, named for Jim Hunter (the man with a bandanna in the front row), who managed the reservoir for the Union Water Company. (Courtesy of the Calaveras County Archives.)

Jim Hunter posed for this photo holding his favorite rifle, bandanna, and wearing a large-brimmed hat. (Courtesy of the Calaveras County Archives.)

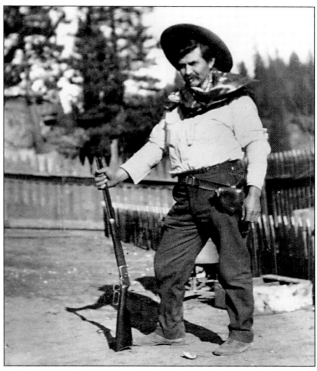

Descendants of several of these families are residents of Murphys and Calaveras County to this day, including those of Nettie Hunter, a longtime Murphys resident whose mother Matilda was born at Squaw (Oak) Hollow in the South Grove of Calaveras Big Trees. Nettie's father was George Hunter, a shakemaker from Nova Scotia. (Courtesy of the Calaveras County Archives.)

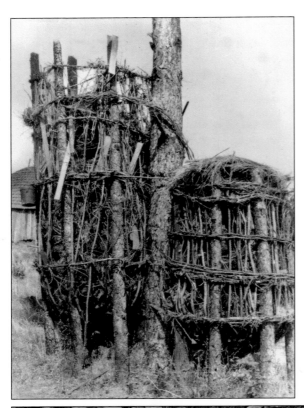

This view of a traditional acorn granary was taken in 1906, when the Mi-Wuk were still using the traditional storage method. (Courtesy of the Lowie Museum of Anthropology, University of California, Berkeley.)

Aron and his friend Moses worked as laborers on several farms around Murphys, and although he had a wife and three children, when Aron died in 1942, he was remembered only as "The Indian." (Courtesy of Wally Motloch.)

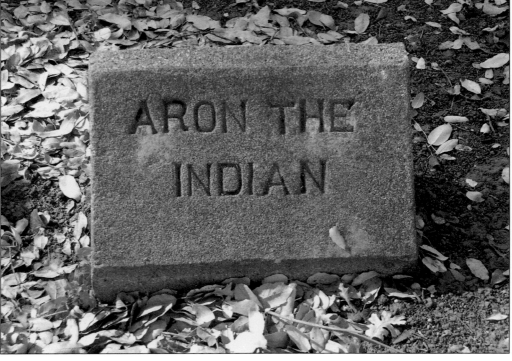

Three

GOLD!

Although it is not known who first mined for gold in Murphys, pertinent evidence points to people of Hispanic origin. Accounts of Mexicans working the flats and streams are found in diaries of Americans who arrived in the area in 1848. There are also accounts of Native Americans assisting with mining and leading miners to specific locations, but there is no indication that they ever sought the precious metal for themselves prior to the arrival of Hispanic people.

The 1848 discovery of gold in California precipitated a worldwide rush of peoples to the Sierra Nevada foothills. Virtually overnight, the land was populated with gold-seekers from the Atlantic seaboard, the Midwest, Mexico, Central and South America, Europe, and Asia. The movement that ensued has been called the greatest mass migration in human history; an economically, ethnically, and culturally diverse population converged upon the Sierran foothills, all in search of the promised gold. Gold was first found in Calaveras County along the banks of Carson's Creek; in the Calaveras Mokelumne, and Stanislaus Rivers; and very soon after in tributaries, where towns such as Murphys, Douglas Flat, and Angels Camp quickly sprang up around the major strikes.

The practice of hard rock mining began in the 1850s, as the source of gold for all the placer and drift mines was determined to be in deeply buried quartz veins. Miners first worked the veins by opening up outcrops in the exposed quartz (pocket mining), then followed the vein by sinking shafts until it became too difficult to hoist the ore. They then developed adits, tunnels, cross cuts, and drifts to reach the ore bodies. None of the early hard rock mines were very successful, however, as the mining technology to extract deeply buried ores wasn't developed until the 1860s in the Comstock Lode in Nevada. During the 1880s and 1890s, a combination of technologies and new funding sources combined to spark the "Second Gold Rush" in California. These included mine timbering technology that enabled the miners to construct deep shafts, tunnels, drifts, and stopes; the development of the Burleigh and other air-powered rock drills; and the infusion of foreign and eastern United States capital. Placer deposits were also processed on an increasingly larger scale to retrieve finer quantities of gold. The mining industry experienced several significant revivals, particularly in the late 19th century and again in the early 20th century.

Murphys was never to become an important lode-mining town, however, as it held no rich gold-bearing veins to compete with neighboring Angels Camp on the Mother Lode. Quartz mining did, however, provide an income for many people for many years continuing through the Great Depression, from ore found primarily in narrow veins and pockets north of town.

Gold was first discovered in the streams and drainages, with some nuggets said to be as large as tennis balls readily available to the first prospectors. Known as placer gold, from the Spanish "in place," the word came to mean gold that was associated with water. In the Murphys area, placer deposits were discovered on Murphys/Angels, Coyote, San Domingo, Indian, and San Antonio Creeks and the various streams and drainages leading into them. (Courtesy of Murphys Old Timers Museum.)

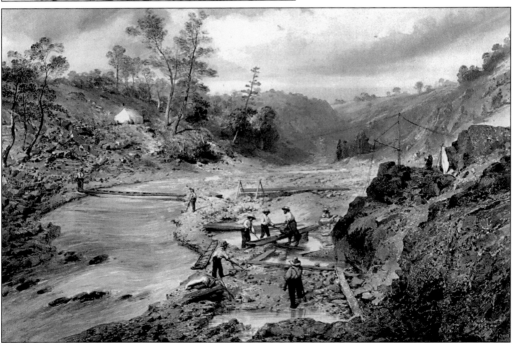

By the early 1850s, the day of the individual miner was over. Most of the easily recovered gold had been picked up, and miners formed companies and raised capital to turn the rivers and creeks and built elaborate wingdams, water wheels, derricks, ditches, and other structures to recover the gold deposited in the river bottoms (Courtesy of Mary Etta Segerstrom.)

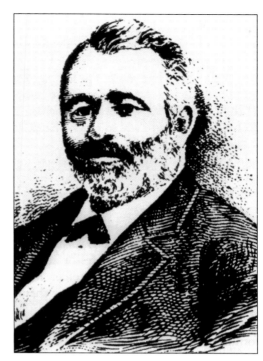

By November of 1849, when the first local election returns were recorded, the town was called Stoutenberg (a corruption of Staudenberg, for a member of the Daniel and John Murphy party), who was evidently the first Euro-American to mine in the valley. By the time elections were held in 1851, however, the town was known as "Murphys New Diggings," the old diggings being in Vallecito. Eventually called Murphys Camp, the community was named for the Murphy brothers, who arrived in August or September of 1848 with a party of miners from Captain Weber's Stockton Mining Company. Pictured are Daniel (above) and John (below) Murphy. John established a trading tent, exchanging provisions with the Indians and marrying the daughter of the chief. By the time he departed for Santa Clara in December of 1849, it reputedly took six mules to carry his gold dust in 17 pouches, as he apparently had more gold than any man on the Pacific Coast. (Both photos courtesy of Marjorie Pierce.)

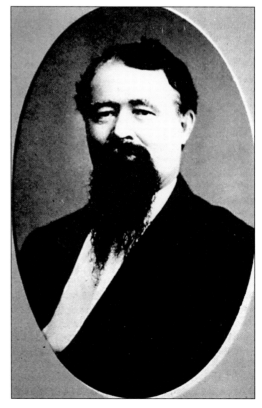

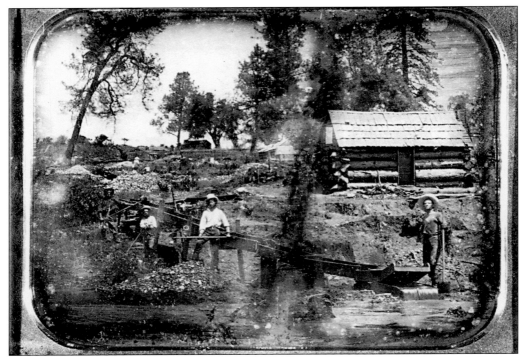

This is one of the earliest known views of miners working in the Murphys area, a half-plate daguerreotype taken by Isaac W. Baker in 1851. The men are washing their gold in a long tom, with piles of waste rock thrown from the riffles piled around. Their shake-roofed log cabin is located to the rear of their diggings. (Courtesy of the Oakland Museum.)

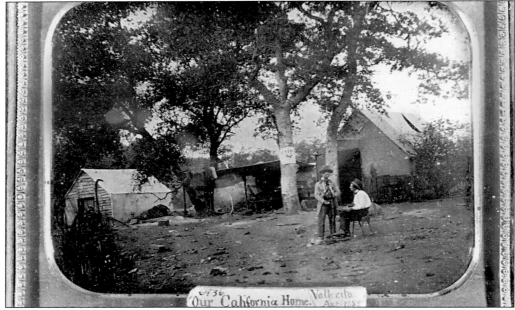

Another early view of miners and their cabin and tent was taken by an unknown maker in Vallecito and entitled "Our California Home, 1853." (Courtesy of Sutter's Fort Museum.)

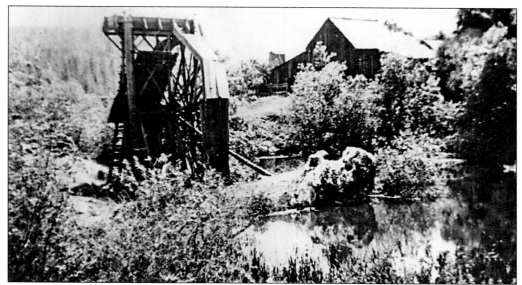

Three major mining areas were located in Murphys: Owlsburrow (or Owlsburg) in the flat behind the Masonic Hall, which was reworked by the Chinese in the 1870s after being abandoned by the American miners; Algiers on Murphys Gulch south of town, where it was claimed that $5 million in gold was taken out; and the flat just below the town, where the rich "Million Dollar Hole" was located. All of these areas were mined down to bedrock, with the exposed limestone visible today. In later years, John and Fred Hauslet built a water wheel on the west end of town, to pump the water and mine the area, but found that it had been worked out in the 1850s and 1860s. Known as the "pump hole," the area became a popular swimming hole for the local children. (Courtesy of the Calaveras County Archives.)

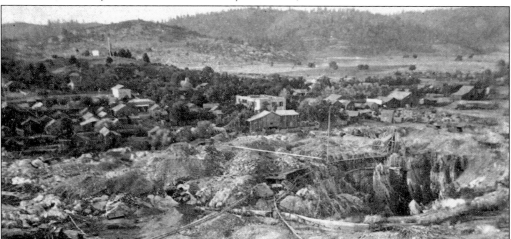

During the 1850s and 1860s, most of the mining activity in Murphys took place on Murphys Flat, where in 1860, over 20 different mining companies were assessed for mining improvements ranging from flumes and ditches, to pipes and waterwheels, to stamp mills. This early stereopticon view of Murphys Flat, taken from the south, depicts the devastation engendered by the workings of these early miners. The view was taken sometime after 1855, when the fireproof-stone Murphys Hotel was constructed by James L. Sperry. (Courtesy of Murphys Old Timers Museum.)

One of the "celestials" posed for this photograph taken by Frank Peek of Mokelumne Hill.

The placer gold was soon depleted, and the industrious miners looked for sources of gold in higher places. Around Murphys, they found gold in the rich gravels of the Tertiary streambeds, many located in ancient rivers beneath the table mountains. The richest of these mines were found in the hillsides above Douglas Flat in the Ohio, Uptograph (Buckminster), Wild Goose, Hitchcock, Texas, and numerous other claims, including the aptly named "Take What's Left." Miners there worked by sinking shafts and running drifts into the hillsides to follow the course of the Tertiary rivers and find the gold in their sinuous channels, as here in the 49 Mine in Douglas Flat. (Courtesy of the Calaveras County Historical Society.)

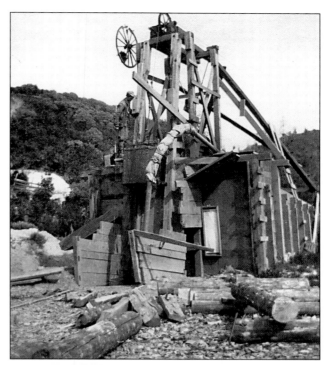

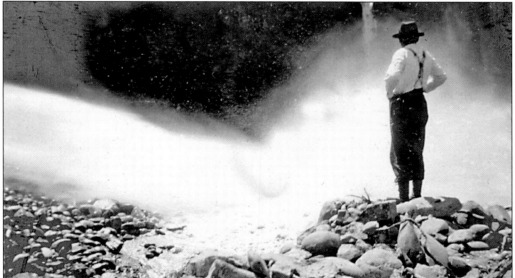

On the opposite side of the table mountain from Douglas Flat, in the Murphy or Central Hill Channel (now the Murphys sewer ponds on Six Mile Road), gold had been discovered as early as 1850, when a 60-foot shaft was sunk to access the paydirt. By January of 1858, the Central Hill Mining Company had completed a ditch and flume from Owlsburg, running a tunnel 1,100 feet through the hill to supply water to the mine, as well as to Six Mile Creek. In 1894, the Central Hill Mine ran a drain tunnel 3,300 feet long from Douglas Flat to work the gravel by the hydraulic process, thus connecting the two areas of diggings. (Courtesy of the Calaveras County Historical Society.)

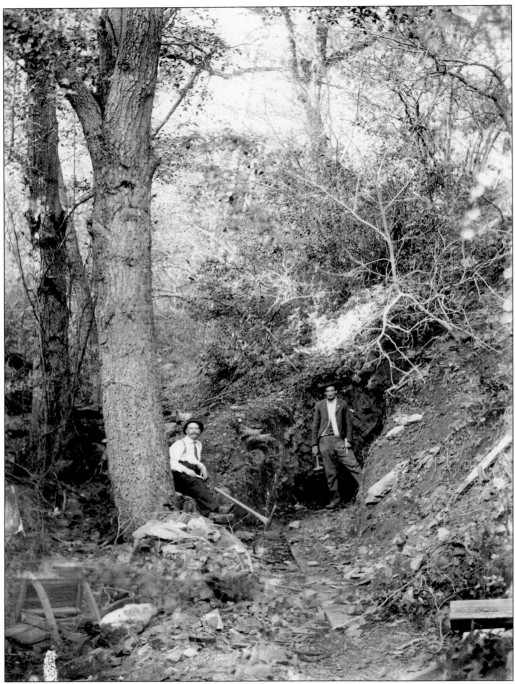

Most of the quartz mines were small one-, two-, or three-man operations that worked the gold by hand in mortars and pestles, in *arrastras*, or in small one- or two-stamp mills. Joe Heinsdorff and another unnamed miner were depicted in this early 1900s photograph, taken at their mine adit on Indian Creek. (Courtesy of the Calaveras County Archives.)

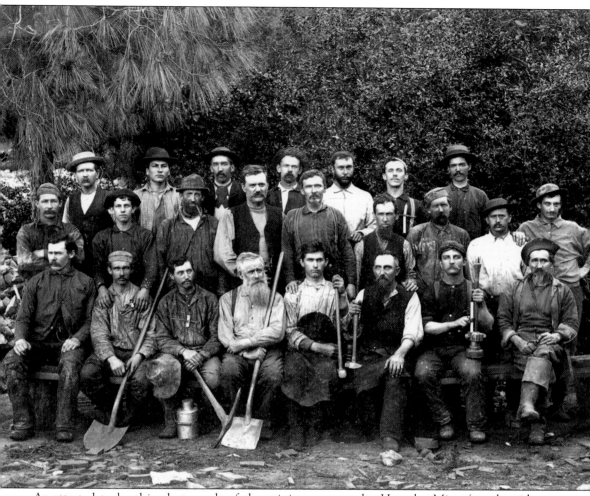

As attested to by this photograph of the mining crew at the Hercules Mine (on the ridge between San Antonio and Indian creeks near Murphys), some mines were evidently paying well enough to employ a fairly large labor force. These miners were photographed in the 1890s with the tools of their trade. (Courtesy of the Calaveras County Archives.)

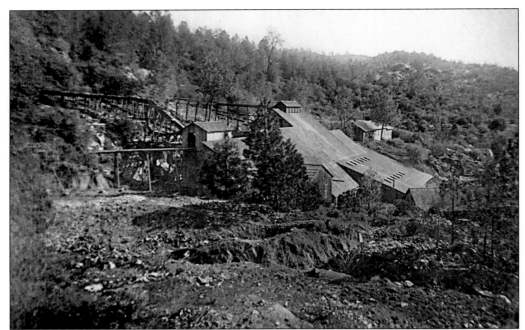

The one large quartz mine in Murphys was the Oro y Plata (gold and silver), located on the ridge north of town. Placer gold was first discovered on Owls Burrow Flat (or Owlsburg) in 1853 (the flat behind Masonic Hall), and shortly thereafter on the hillside to the north. A great deal of money was expended on mining and milling improvements to the mine during the 1880s, including a 15-stamp mill and a chlorination plant erected on the Blue Wing Claim. Although the substantial outlay of capital was never rewarded with any great monetary success, the Oro y Plata mines were the most productive in Murphys. Note the two ore chutes to the gravity-fed concentrating plant, where the coarser quartz sands were recovered. The coarse rock was sent to the concentrating mill where the ore was sent through a rock breaker, then dropped into an ore bin, from which it was fed to the Tustin pulverizers, and treated finally by roasting and chlorination. Also note the early diggings in the foreground. (Courtesy of Milton B. Smith.)

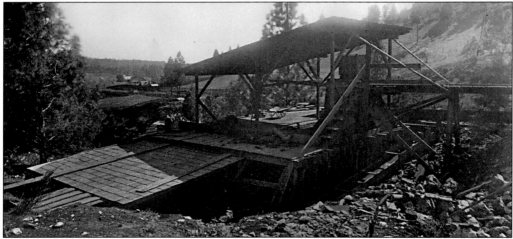

This view shows the collar of the Blue Wing shaft on the hillside north of the mill, southwest towards Murphys. (Courtesy of Milton B. Smith.)

34

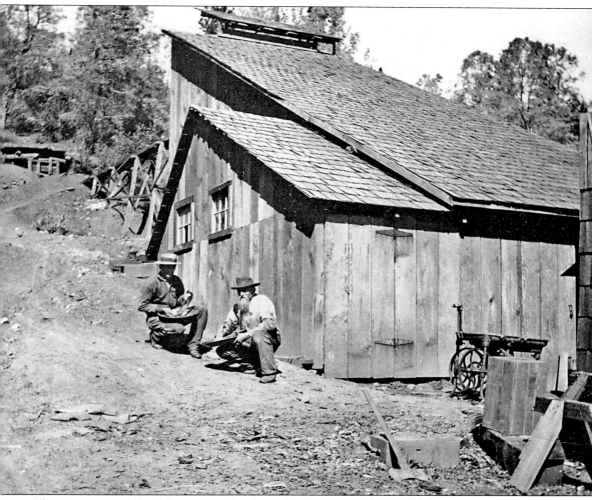

This is a view of the 15-stamp mill, where the finer-grained parts of the quartz-sand were recovered. (Courtesy of Milton B. Smith.)

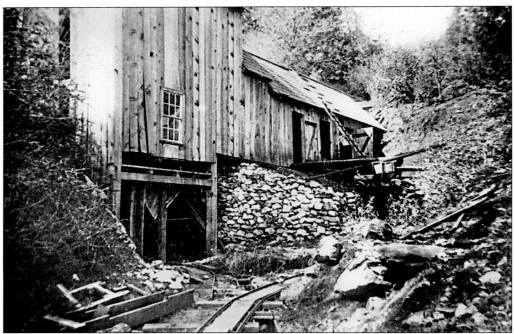

The mill buildings, on stone footings, were of frame construction, with vertical board and batten siding, shake roofs, and six-over-six light frame windows. (Courtesy of Milton B. Smith.)

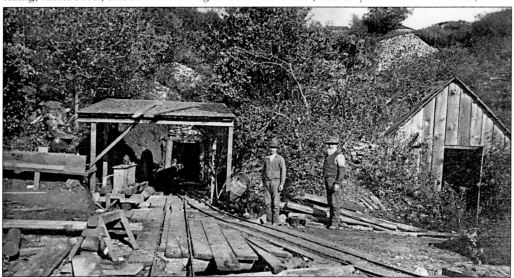

Pictured are the adit and mine entrance to the lower elevations of the glory hole, which collapsed during a February 1887 rainstorm. The man in the beard is F.B. Morse, the mine superintendent. The owners tried to recoup the losses by mortgaging the property to Boston entrepreneurs, but the mine remained idle until 1926, when it was purchased by the Union Consolidated Mining Company, which constructed a 50-ton mill with a jaw crusher, ball mill, Harz jig, rake and classifier, and four flotation cells. Twenty-six men were employed, about the same as in 1886. Operation ceased in 1931, but the Orion Mining Company reworked the tailings in a cyanide plant from 1936 to 1938. (Courtesy of Milton B. Smith.)

Four

TRAILS, ROADS, AND WAYSTATIONS

The earliest fixed routes in the area followed established Indian trails, used for thousands of years by Native American groups traversing the high mountain passes between the Great Central Valley, the Sierra Foothills, and the Carson Valley. Other trails ran north and south, connecting Native American watering places, villages, and hunting and gathering areas. Jedediah Smith was evidently the first Euro-American traveler to use the present trans-Sierran route when he crossed the Sierra Nevada in 1827. By 1849, however, it was in use by several parties, many of whom gave descriptions of the Big Tree Grove in their diaries.

Several exploration parties attempted to establish routes over this central portion of the Sierra Nevada. Major John Ebbetts, the man for whom the Highway 4 pass is named, crossed over the Sierra in April of 1850 with a large group of prospectors. The name was not bestowed upon the pass until after the summer of 1853, when Ebbetts, then in the employ of the Atlantic and Pacific Railroad Company, surveyed the route for a trans-Sierra railroad. The pass was formally named in 1854 by George H. Goddard, a close friend and member of the 1853 exploration party.

The general route of the current Highway 4 was certainly used by Leonard Withington Noyes, who, prospecting on the way, investigated the Calaveras Big Tree and traveled as far as Grizzly Bear Valley by 1853. As part of the Murphys Expedition that journeyed east over the crest and down into the Carson Valley in 1855–1856, Noyes was investigating the route of a future wagon road. According to Noyes, who left behind a journal written during the building of the Big Tree Road, work began in July and by September he was escorting emigrants across the trail. In 1856, this route—a simple straightening of the 1849 Emigrant Road—became known as the Big Tree to Carson Valley Road. Financed by a group of Stockton businessmen at a cost of $7,000, the road included seven bridges and was intended to bring travelers from the east into Stockton rather than Placerville. (Courtesy of the author.)

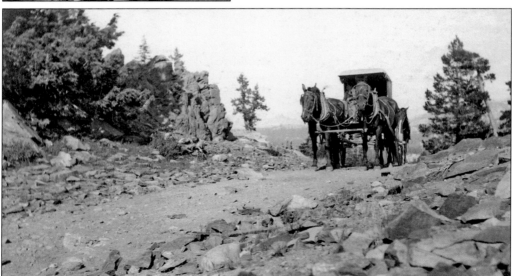

During the winter of 1861–1862, a group of Murphys men organized the Big Tree and Carson Valley Turnpike Company and raised $4,000 to build a road from the Big Tree to the Silver Mountain and Monitor areas of Alpine County. Starting in the vicinity of the present Calaveras Big Trees State Park, this road was another improvement on two earlier roads to the Carson Valley and reflected the importance of the silver discoveries in Alpine County and Nevada to trans-Sierran travel. (Courtesy of the author.)

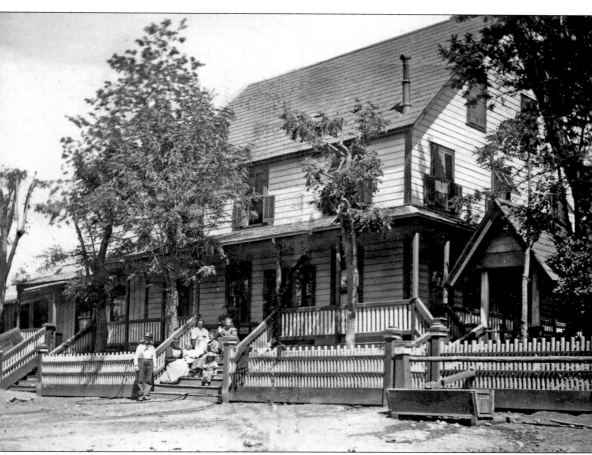

Virtually all of the original stopping places along the Big Tree(s) route were established as ranching and grazing operations that provided sustenance to travelers and stockmen during the summer months. These included Avery's, Dunbar's/Arnold, Cold Spring Ranch/Gardner's Station/Dorrington, Hinkleman Meadow, Mill Creek Station, Cottage Springs, Mud Springs, Black Springs, Big Springs, Ganns, Big Meadows, Onion Valley, and Blood's Meadow. Horses could be watered, fed, and exchanged, and travelers were also able to find a bed, or at least a floor, and a meal. The stopping places have remained on the land as local place names that are still depicted on current maps. The closest of these above Murphys was at Halfway House (Avery Hotel) as it was halfway between Murphys and the Big Trees, where Joe Goodell settled the land about 1850, building a four-room house for his family. Peter and Nancy Avery purchased the house in 1854 and enlarged and remodeled it into a stage stop. The original house was remodeled again in 1874 after the death of Peter, and in 1886 George Avery built the two-story addition. (Courtesy of the Calaveras County Archives.)

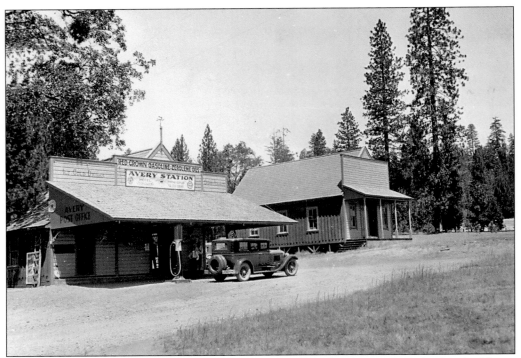

The property included a store, a dance hall, a post office, barns, corrals and other buildings, which remained in the family until 1944. By the 1920s, Avery boasted a Red Crown gasoline station and a general store to serve the local residents and the increased traffic over the route. (Courtesy of the Calaveras County Archives.)

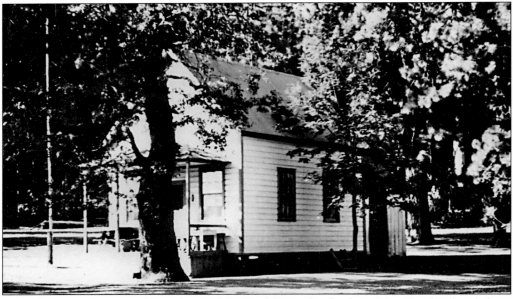

In the late 1880s, George Avery donated the land for a school, where Miss Hazel Fisher (whose name was bestowed on the new school in Arnold) of Avery taught for over 25 years. (Courtesy of the Calaveras County Historical Society.)

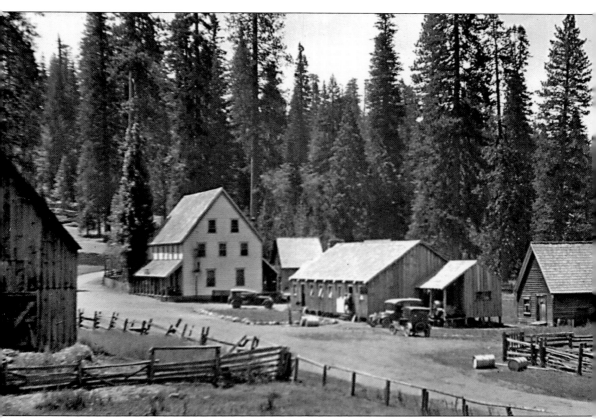

The next stop was at Dunbar's, now known as Arnold, where the Willis Dunbar family of Murphys had an 880-acre ranch that provided meat, vegetables, timothy hay, potatoes, and fruit (primarily apples) to nearby resorts and lower elevations from the late 19th century into the 20th. After a stop at the Big Trees Hotel, the one exception to this pattern of establishing waystations at ranches, travelers continued to Dorrington, where John and Rebekah Gardner, had purchased the Cold Spring Ranch in 1868. Rebekah's maiden name, Dorrington, was given to the first post office. The present hotel was constructed in the 1880s, after a fire destroyed the earlier building. (Courtesy of the Calaveras County Historical Society.)

An Angels Camp family appeared to enjoy the respite from the summer heat of the foothills on the Dorrington Hotel porch in the early 1900s. (Courtesy of the Calaveras County Historical Society.)

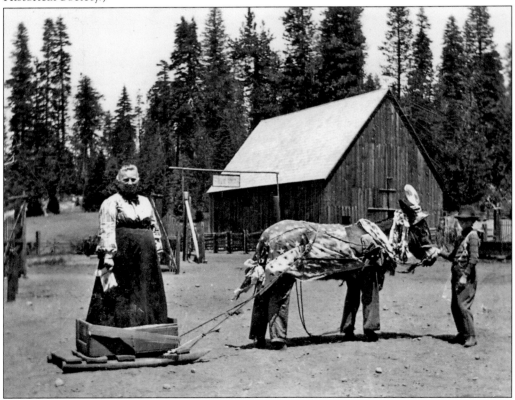

In 1903, the Fourth of July was celebrated at Gardner's ranch by decorating the family donkey. (Courtesy of the author.)

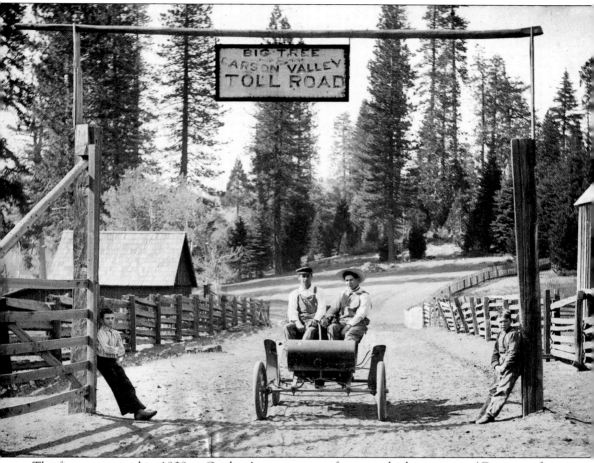

The first car arrived in 1908 at Gardner's, a precursor of many vehicles to come. (Courtesy of the Calaveras County Archives.)

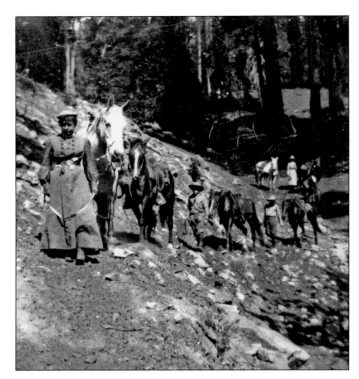

For many years, the stockmen and their families used the high country route to access their summer stock ranges. This pattern of transhumance (the upland grazing of cattle, sheep, and goats) continues to this day, but with livestock being transported by trucks rather than horses. In this c. 1900 photo, rancher Ethel Adams leads her horse, followed by a group of horsemen, on their way to the high country. (Courtesy of the author.)

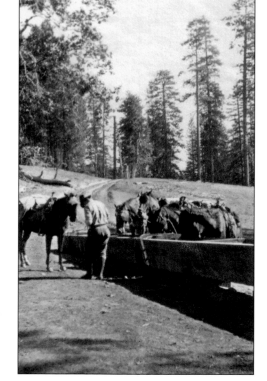

These horses are being watered at the Big Trees along the old highway on their way to the mountains. Their names are Nellie, Prince, Girlie, Nancy, and Pony; the man is Lester Canevaro. (Courtesy of the author.)

The first owner of the land in what was originally known as Grizzly Bear Valley was William Dennis, who obtained title in 1860. In the spring of 1864, he sold to Harvey Blood of Angels Camp, who used it as a summer stock range, and the area became known as Blood's Meadow. The station became the main tollgate after Blood acquired the Big Tree–Carson Valley Turnpike. (Courtesy of the author.)

In later years, the Lombardi family leased Bear Valley for their summer range, where Louis Lombardi posed by the door of their cabin. (Courtesy of the Calaveras County Archives.)

Harvey Blood was a resident of Angels Camp and served in the State Assembly in the 1890s. He married Elizabeth Gardner, daughter of John and Rebekah, and the couple had one child, Reba Blood, pictured here, for whom Mt. Reba and the ski area are named. (Courtesy of the Calaveras County Archives.)

The advent of the automobile led to the development of many of the more recent settlements on the Ebbetts Pass route as more and more families took to the mountains to partake of the clean rivers, lakes, and cool forests. (Courtesy of the Calaveras County Archives.)

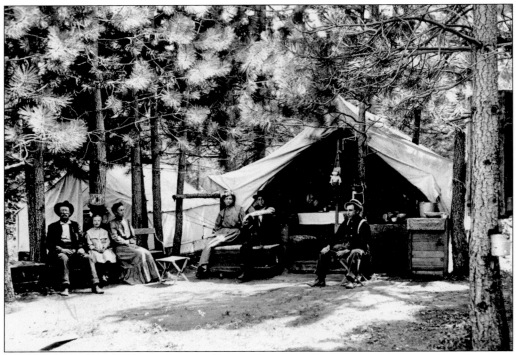

This family is enjoying the outdoors in their well-organized campsite. (Courtesy of the Calaveras County Archives.)

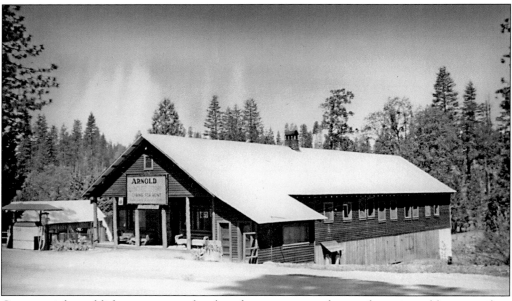

Commercial establishments were developed to serve travelers and tourists alike, providing automobile services, sustenance, and lodging. Arnold was founded on one of these establishments, and received its name form Bob and Bernice Arnold, who in the 1930s began operating a bar, restaurant, and three cabins there. (Courtesy of the Calaveras County Archives.)

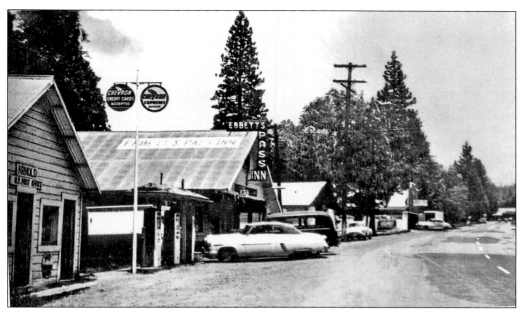

This business became the nucleus for several other commercial enterprises, all catering to the traveler. (Courtesy of the Calaveras County Historical Society.)

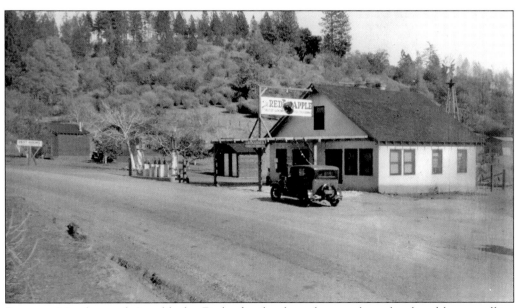

Between Murphys and Arnold, the Darby family planted an apple orchard and began selling apples, juice, pies, doughnuts, and other apple products to travelers on their ranch at "Red Apple." (Courtesy of the Calaveras County Archives.)

Camp Tamarack, in the upper reaches of Calaveras County, was originally known as Onion Valley and used as a summer stock range for more than 80 years. The first store was built by W.H. Hutchins in the early 1920s. In 1934, William and Ruby Bracey purchased the land in 1934 and built a store and two rental cabins. The present lodge was built by the Mosbaugh family of Arnold in 1956. (Courtesy of the Calaveras County Historical Society.)

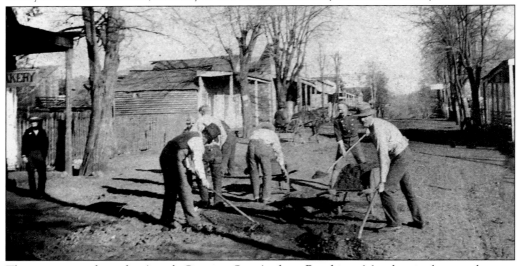

The main route from the Angels Camp to San Andreas Road into Murphys in those early years was known as the Hawkeye to Murphys Road (near Cosgrave Road on present Highway 49 between Angels Camp and Fourth Crossing). Established in 1854, this road ran from Hawkeye (on present Highway 49) to Murphys via Webbs Ranch, intersecting Dogtown Road, and the French Gulch Road. At that point it branched to French Gulch, via Washington Flat, to Vallecito and on to Murphys. By 1858, the Six Mile Road was known as the "old road to Murphys," suggesting that it, too, was once an important route. The route of the present Murphys Grade Road was not established until 1865, when the Murphys and Altaville Road Company constructed a toll road along this more direct route. It remained a private toll road until declared a free public road by the Calaveras County Board of Supervisors in 1911. The roads were unpaved, which required regular upkeep by the townspeople, shown here in the early 1890s smoothing out the wagon ruts. (Courtesy of the Calaveras County Historical Society.)

Five

WATER AND POWER

In the earliest years of the Gold Rush, virtually all settlement sprang up around the gold discoveries and their supply camps, primarily along the streams and rivers where the placer gold was mined. With the advent of hard rock mining, however, towns were built near productive vein mines, often far from natural sources of water. The ditch and flume systems developed to bring water to the diggings were expanded to reach the quartz mines, which needed water to operate their *arrastras*, stamp mills, and hoists. These first mills were usually powered by overshot wheels or by steam, fed by streams of water. Steam boilers were introduced, which also used great amounts of water. Later, impulse wheels which used less water but greater pressure, were introduced. After the advent of electricity, it was still water that powered the wheels and turbines.

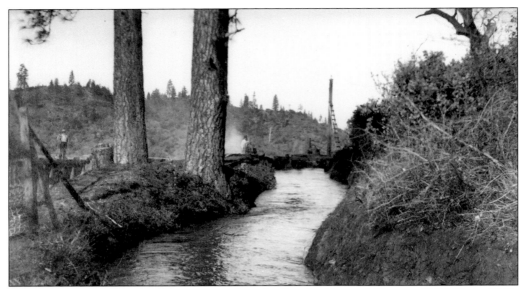

From its organization in 1852 to its purchase by Pacific Gas and Electric (PG&E) in 1946, Union (and later Utica) constructed dams, ditches, flumes, and watercourses, purchasing virtually every other ditch and flume company that tried to operate within its sphere. In this early 1900s view, the ditch courses along the hillside above Murphys, as it has for over 150 years. (Courtesy of the Calaveras County Historical Society.)

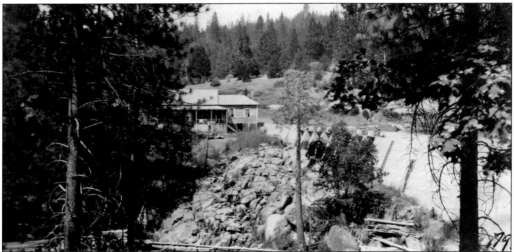

In need of more water, the company was incorporated in 1854, with a capital stock of $200,000. The system was expanded to the Stanislaus River, where they constructed a timber-frame dam. A log-crib dam was constructed at Union Reservoir in 1858, quickly followed by dams at Elephant Rock Lake, Summit Lake, and Duck Lake. In 1859, John Kimball and Ephraim Cutting purchased the steam sawmill of William Hanford, which had been established at the site of present Hunter Reservoir in 1855, thus assuring the company of a steady supply of lumber for flume construction and repair. In the 1870s, Kimball and Cutting became the major stockholders of the Union Water Company, and the system was greatly expanded under their leadership. This early view of Hunter Reservoir was taken sometime prior to its 1927 expansion. (Courtesy of the Calaveras County Archives.)

The Union Water Company, established January 1852, was a combined effort of two rival companies that organized to bring water to the miners. The first fountainhead was located at the junction of Union (Love) and Sawmill (Moran) creeks, about 10 miles above town. Two other reservoirs were soon built to divert water into the bed of Murphys Creek, following the natural channel toward town, from where the North Ditch swung out above Owlsburg to the Oro y Plata Mine before reaching Murphys Flat, while the South Ditch branched down the creek to the diggings on Murphys Flat and Douglas Flat, and later as far as Balaklava Hill (east of Parrotts Ferry Road near the Stanislaus River). Sawmills, blacksmiths, construction camps, and tender houses were built adjacent to the watercourse to provide lodging for the workers who built and maintained the ditches, flumes, and reservoirs. (Courtesy of the Calaveras County Historical Society.)

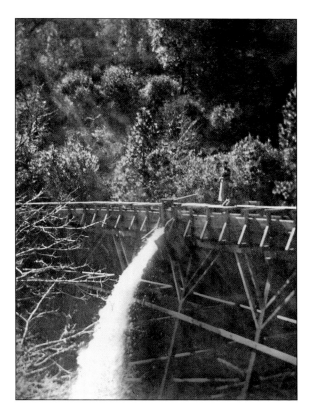

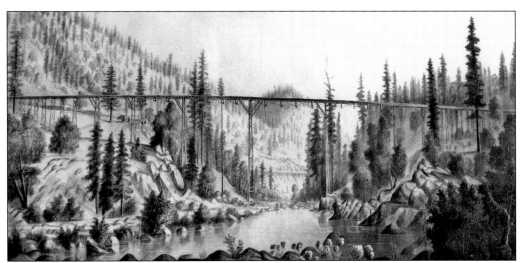

In November of 1857, a suspension flume was erected across the lower end of town to carry water from the North Ditch to the Central Hill Mine, where miners were working the Tertiary gravels on present Six Mile Road. The north bridge tower was 94 feet high and the south 124 feet, 740 feet from tower to tower. The flume was destroyed in a windstorm two years later and replaced by a pipe, then by a siphon that was in use until the mine closed in 1898. (Courtesy of Murphys Old Timers Museum.)

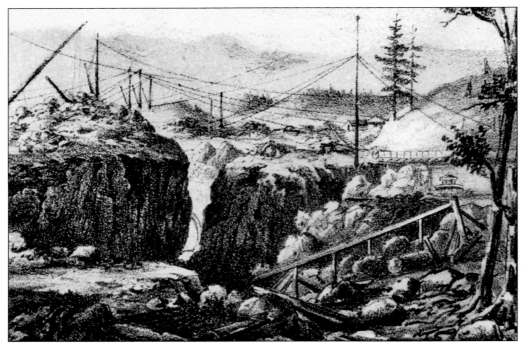

The water that was brought into Murphys by the Union Company created a new set of problems: the flat became indundated, and the mines flooded. In 1859, the Deep Cut, a ditch dug and blasted out of bedrock 4,000 feet long and 37 feet deep, was cut south of town to drain the flat so mining could continue. (Courtesy of Murphys Old Timers Museum.)

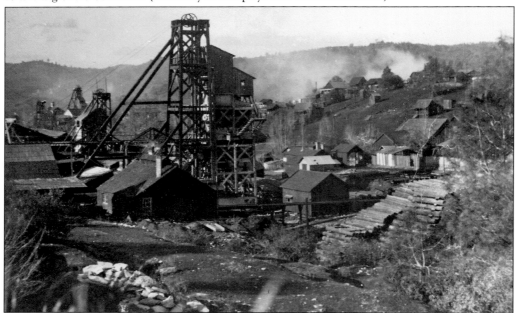

Over the following years, the system was improved many times, especially after its 1880s acquisition by the Utica Gold Mining Company of Angels Camp, which by then was the most powerful entity in Calaveras County. (Courtesy of Wally Motloch.)

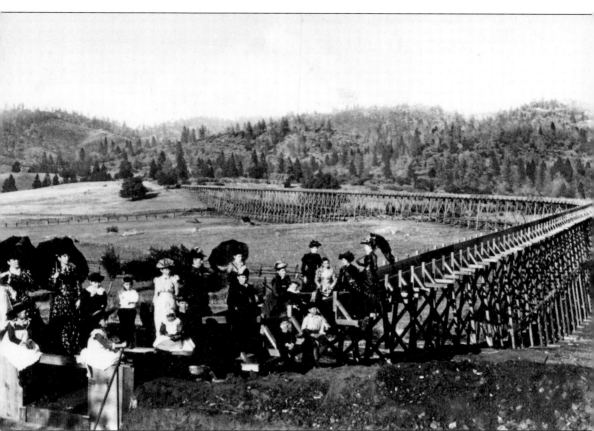

By 1868, the Union had also acquired several miners' ditches, as well as the ditch and flume system of the Calaveras Water Company, established in 1856. The company then combined the two systems, abandoning much of its earlier system of flumes, which was subject to the vicissitudes of fire and weather. A connecting ditch was constructed at the "Forks of the Ditch" on Pennsylvania Gulch Road below Forest Meadows. The flume of the South Ditch crossed the road to Vallecito, where this group of local ladies found an ideal picnic spot in the early 1890s. The flume was torn down in the mid-1890s, and the water was transported by ditch. (Courtesy of Murphys Old Timers Museum.)

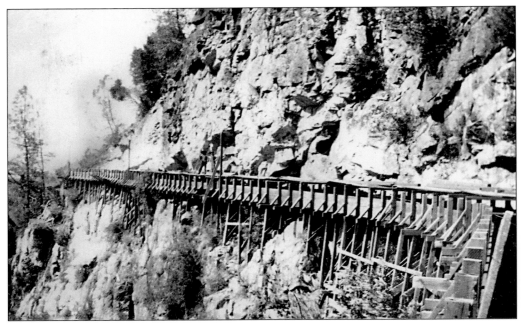

It was during the ownership of the Utica Company that most of the major expansion of, and improvements to, the system were made. The "Three-Quarter Mile Flume," named for its distance, was constructed near Red Apple, and photographed in the early 1900s. It burned and was rebuilt in the early 2000s. (Courtesy of the Calaveras County Historical Society.)

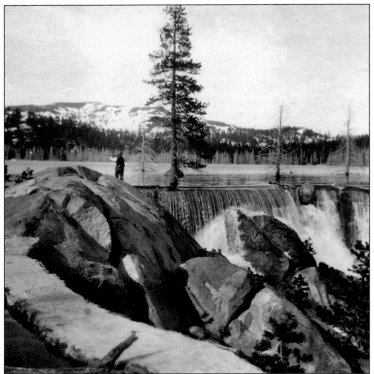

After its takeover by the Utica Company, one of their first actions was to dam the waters of Silver Creek, constructing Alpine Dam in 1889 and creating Alpine Lake. The dam was built of granitic boulders, mortared with concrete. (Courtesy of Murphys Old Timers Museum.)

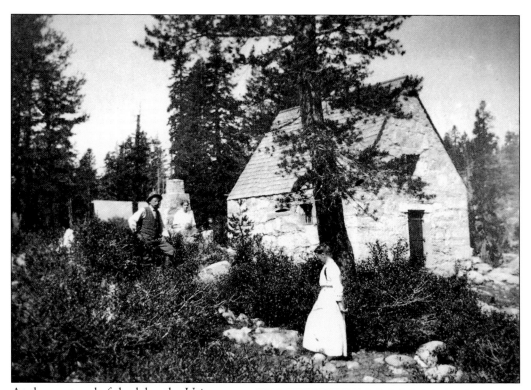

At the west end of the lake, the Utica Company built the "Stone House" as a supply cabin to be used during construction of the dam. When the Utica Reservoir was constructed in 1905, cement was shipped by railroad to Angels Camp, then hauled by four- and six-horse teams to the Stone House for storage, before being hauled over Slickrock Road to the site. Granitic blocks, blasted and shaped, were used to form the cabin walls, with iron shutters on the doors and windows. A large granitic stone chimney, facing the cabin, is located a few feet south and apparently served a log or frame structure, while a log barn is located up the hill. (Courtesy of the Huberty family.)

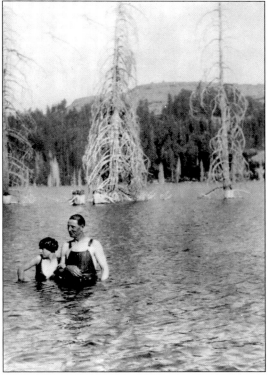

The Silver Valley (Alpine) Dam was raised 1903–1906, and the Utica Reservoir enlarged in 1908–1910. Historian Coke Wood, right, and a friend take a swim in Alpine Lake in the 1920s, which by then had become a popular tourist destination. (Courtesy of Murphys Old Timers Museum.)

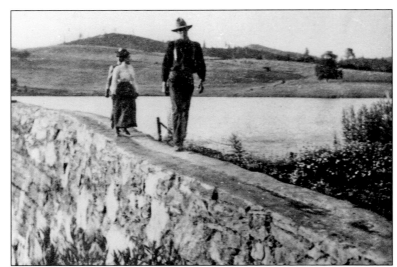

Earlier and closer to the mines, dams were built at Ross, Johnson, and Lane to form new reservoirs. Ross Reservoir at the Ross Ranch on French Gulch Road was constructed in 1893–1896, and became a popular picnic spot. (Courtesy of Judith Marvin.)

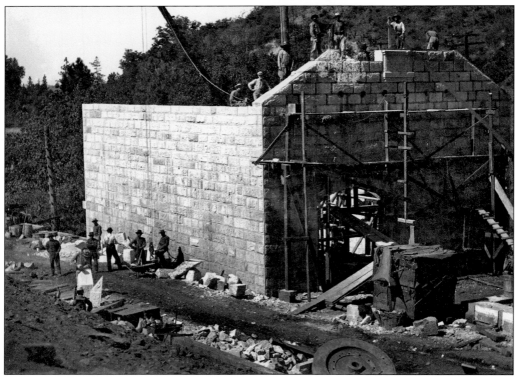

Besides providing water to the Utica Gold Mining Company's mill in Angels Camp, its canal supplied the mine, via a hydroelectric plant, with the first electricity produced in Calaveras County. In 1899, the Utica's new subsidiary, Angels Electric Light and Power Company, built a hydroelectric plant on Murphys Creek, its generator powered by water delivered through a penstock from Tank Reservoir on the hill above. The powerhouse was built with blocks of rhyolite tuff, quarried on the Adams Ranch on Pennsylvania Gulch. It was 50 by 37 feet, with the downstream gable end closed by a temporary sheet metal wall to allow for expansion. (Courtesy of Martin Huberty.)

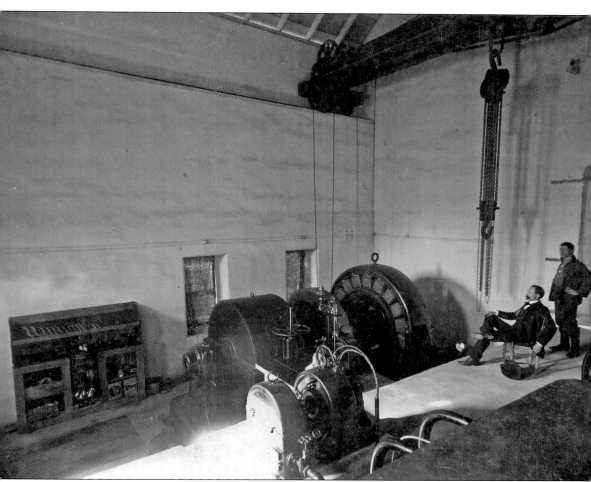

In this 1901 photograph, the company engineer relaxes while watching the two Westinghouse generators, directly connected to a 12,000-horsepower Pelton impulse waterwheel. Power was then carried over an 8-mile-long pole line to the substations at Angels Camp, where a battery of transformers stepped down voltage for distribution to its customers. (Courtesy of Martin Huberty.)

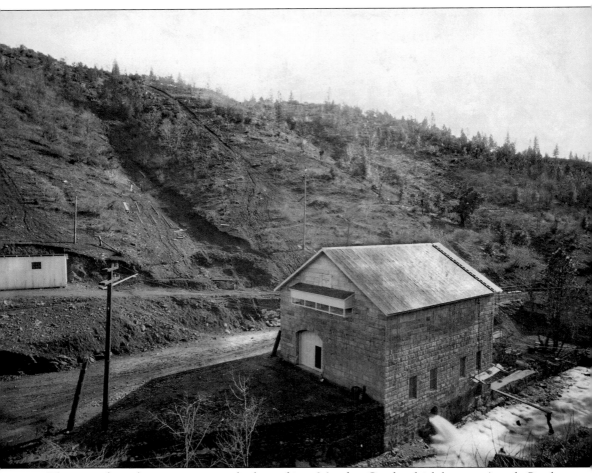

The water from the generators was discharged into Murphys Creek, which became Angels Creek at the Park. From there it was carried by flume and ditch to its terminus in Angels Camp. After the mines served by this system closed in World War I, the company signed agreements with various water users' associations for delivery of water for agricultural and domestic purposes. When the last of the mines closed in 1942, the company began negotiations with PG&E, who purchased the entire system in 1946. This ushered in a new era for the system that was built on the dreams of men who tried to wrest the golden riches from their foothill matrix. The Utica Power Authority acquired the system in 1997, but water to Murphys is still delivered by the Union Public Utility District, which retains the 1852 company name. (Courtesy of the Calaveras County Historical Society.)

Six

COMMUNITY

The community of Murphys has changed dramatically since it was described by a visitor in October 1848 as a camp in the midst of a tribe of Indians who traded gold with Mr. Murphy in exchange for provisions. Murphy was well respected by the tribe because he had married the daughter of its chief. By 1849, the community was reportedly inhabited by 50 people and consisted of one main street, one frame shed, and tents housing miners, "grog shops," and gambling tables. German philosopher Frederick Gerstaecker, in April 1850, described the town as follows:

> There was a woody plain in the midst of which a small town rose, a broad street of large store tents extended 'along the middle of the flat where not only the necessary provisions and unnecessary drinks might be had, but also real articles of luxury. The main street being thus solely occupied by the different stores and shops, a mass of small blockhouses and tents lay behind them, scattered as far as the next range of hills.

Just seven years later, in 1857, a reporter for the *San Andreas Independent* noted that the "Queen of the Sierra" also had a large number of families for a mining camp located so high up in the mountains and that many of the families' residences were elegantly built and boasted every convenience. In 1859, the town had "a most homelike and prosperous appearance," having more of the appearance of an East Coast town than any other place in the county. Streets were laid out with shade trees, houses were well-built and well-furnished, and gardens surrounded all of them.

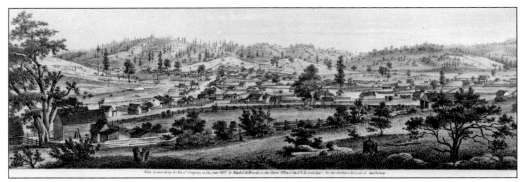

The original habitations were rapidly replaced by wood, brick, and stone buildings, but not until the town had burned several times. The major businesses in the early years consisted of saloons, boardinghouses, restaurants, barbershops and bathing establishments, blacksmith shops, livery stables, miners' supply stores, an opera house and a lumberyard. By the time this lithograph was made, the town was well established. (Courtesy of Murphys Old Timers Museum.)

Miner's Exchange.

MURPHY'S.

J. L. SPERRY,........Proprietor.

This Hotel has lately been enlarged and greatly improved, and now offers every convenience for the accommodation of Families.

Suits of Bed-rooms have been fited up, and Parlors for the sole use of Ladies. Parties visiting the Mammoth Tree Groves, or the other great natural curiosities which abound in this vicinity. will find the accommodation of the establishment unsurpassed in the State.

The Stages to Sacramento, Stockton and Sonora, leave, and arrive at this house daily.

By 1852, when the town was visited by a reporter from the *San Joaquin Republican*, the community had grown exponentially and was known simply as Murphys, having dropped the "Camp." It had 3,000 permanent and floating residents and improvements included 500 substantial frame houses, 8 taverns, several boardinghouses, two restaurants, an express and banking office, livery stable, 7 blacksmith shops, 9 carpenter shops, 4 barns, 5 butcher shops and markets, 2 steam sawmills, a cider and syrup manufactory, a bowling alley, and innumerable dance and drinking houses. Philip Birmingham was busily constructing his large three-story hotel, soon to be purchased by Sperry and Perry. (Courtesy of the Miners and Business Mens Directory.)

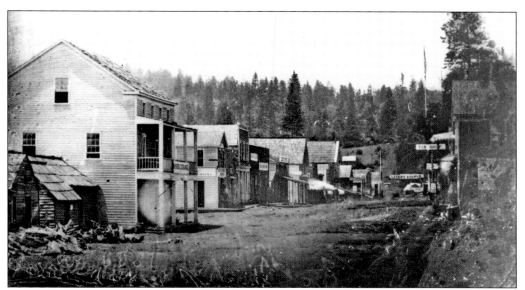

In this earliest known photograph of Murphys, a daguerreotype taken by Baker & Batchelder in 1853 looking westerly down Main Street, Birmingham's Miners Exchange is in the left foreground (the approximate location of Murphys Hotel). Several two-story, gable-roofed buildings continue unbrokenly down the street, packed close together with many lots only 23 feet wide. (Courtesy of the Oakland Museum of California.)

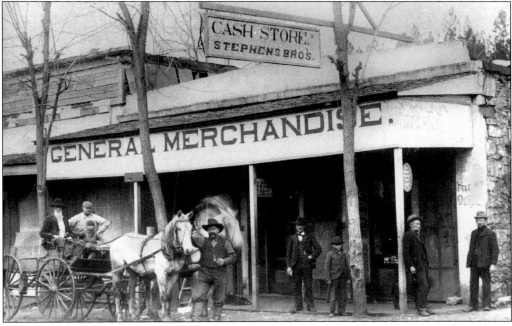

The first fire to consume Murphys occurred in 1854, when a lantern in one of the frame buildings overturned and fire consumed all the buildings on the south side of Main Street. The first fireproof stone building to be constructed dated to after this conflagration: the P.L. Traver stone store (the present Murphys Museum), completed that same year. (Courtesy of the Calaveras County Historical Society.)

The earliest residences in Murphys, several of which predate the extant 1854 assessment records, were of frame construction; vernacular examples of higher architectural styles found in the eastern United States. By the mid-1850s and continuing through the 1860s, most of these homes were constructed in the simple Vernacular Greek Revival style, with two to four rooms in the rectangular main section and either a shed-roofed or cross-gabled kitchen in the rear. This house, photographed in the early 1900s, was typical of many such in town. (Courtesy of Judith Marvin.)

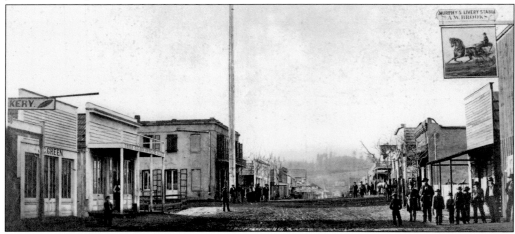

Taken in 1861, this view shows the two frame buildings occupied by Green and the Union Saloon and Bowling Alley, the stone Murphys Hotel, and a series of frame buildings, no longer extant, on the south side of Main Street. The Murphys Livery Stable of A.W. Brooks was located on the north side of the street (now the location of Grounds), while the brick Jones Apothecary (later the Stephens Bros. General Store on northeast side of Main and Algiers streets) is depicted farther down the street. Note the Liberty Pole by the hotel, which was erected in many communities in California in support of the Northern side during the Civil War. A major fire in August of 1859 burned all the buildings on Main Street except for Traver's stone store, the Renaud and Metz stone bakery (then located in front of the red barn on south Main Street), and a stone liquor store on the opposite side of the street. (Courtesy of the Calaveras County Archives.)

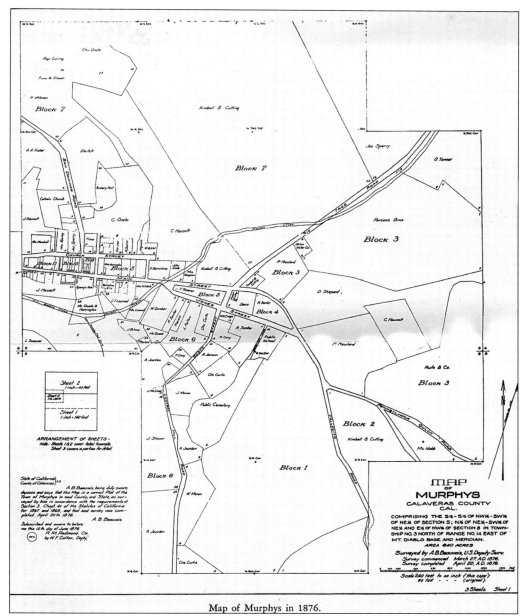

Map of Murphys in 1876.

Another disastrous fire visited Murphys in June of 1874, taking every wooden building between Sperry's Hotel and Raulin's Store (Renaud and Metz), on the south side, and everything between Senter's (Traver's) store and Compere's stone store (northeast corner of Church and Main) on the west end of Main Street. Little was done this time to rebuild the business district and Murphys never again had the large commercial section that it boasted in the 1850s and 1860s. Small lots were combined to make larger, more practical residential lots; a pattern that continued until recently, when the large residential lots were developed for boutiques and restaurants. The town was quickly rebuilt however, and the townsite patented February 15, 1876. A map of the lots and owners was filed by surveyor A.B. Beauvais in April of that year. (Courtesy of the Calaveras County Archives.)

65

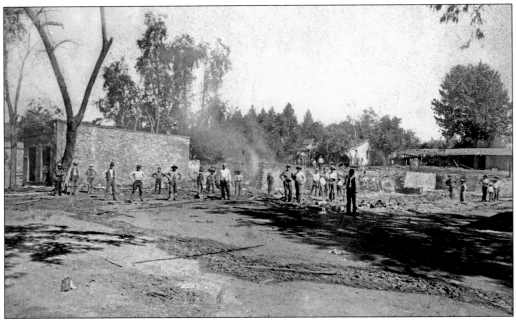

The third major fire in Murphys occurred in late July of 1893 when an explosion in a warehouse behind the Manual and Garland (Traver) store destroyed the Matteson and Garland livery stable and several other structures. All of the buildings in the block east of the explosion were burned except for the brick Union Water Company Office (to the left in the photograph). The townsfolk gathered to have their photograph taken while smoke was still issuing from the site. (Courtesy of the Calaveras County Archives.)

By this time, mining in Murphys had declined and the town was known more as a supply center for the surrounding mining areas of Douglas Flat, Sheep Ranch, Indian Creek, French Gulch, and others. It had also gained notoriety as the gateway to the Natural Wonders: the Calaveras Big Trees, Mercer's Caverns, Natural Bridges, Cave City, Moaning Cavern, and San Antonio Falls. The early preponderance of saloons had given way to mercantile establishments, jewelry shops, stage companies, butcher shops, general stores, and other businesses catering to the more permanent residents. (Courtesy of the Calaveras County Historical Society.)

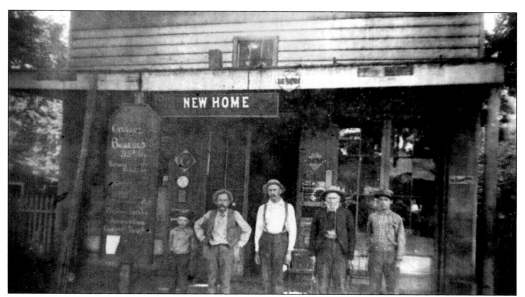

Certainly the most frequented and popular establishments in the early days were the saloons, a few of which are still extant. W.C. Crispin's Saloon on the west end of Main Street, now marked by a monument, was one of the best known. One of the oldest frame buildings remaining in town, Freeman, Dunbar & Company's saloon was built soon after the fire of 1859. W.C. Crispin moved his saloon business here in the 1870s, and in the 1880s the Fisk family continued in the same line of work. By 1891, when this photograph was taken, it had been converted to a grocery store. (Courtesy of the Calaveras County Historical Society.)

Fred Sackett, a well-known Murphys saloonkeeper, operated his saloons in different buildings at various times. In 1890, on one of his few days off, he took his wife Vera for a buggy ride. (Courtesy of the Calaveras County Historical Society.)

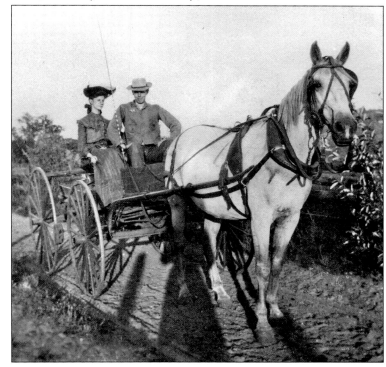

Most of the stone and brick buildings in Murphys were constructed as commercial establishments, primarily as stores and saloons. The P.L. Traver Dry Goods Store, the oldest extant stone building in town, was built in 1854, selling groceries and provisions for the miners. It was later operated by Riley Senter as a store, then by Manuel and Garland, the Stephens brothers, and others. The building was used as Morley's garage and extensively altered during the 20th century, and then remodeled as a residence and museum by Richard Coke and Ethelyn Wood. (Courtesy of Wally Motloch.)

Immediately west of the Traver Store and sharing a common wall, John Thompson, a stone mason and operator of the lime kilns on Rocky Hill, built a general store on the site of the "Cottage House." After his death, it was operated by his widow, and then in the late 1860s by Oser Meyer and his son-in-law Herman Friedlander as a general merchandise store. (Courtesy of Otheto Weston.)

One of the first commercial establishments to be completed after the fire of 1859 was the simple brick and stone Greek Revival apothecary store of Dr. William Jones, built on the site of the earlier New York Store. (Courtesy of the Miners and Business Mens Directory.)

Dr. Jones operated his drugstore from the building, and his office from a small frame building adjoining the east wall. The building was then sold to John Hauslet, who rented it to the Odd Fellows for use as a hall from 1867 to the early 1890s. The Stephens brothers operated their general store in the building in the late 1890s and their sign advertising the "Stephen Brothers Cheap Cash Store" is still visible on the west wall. (Courtesy of the Calaveras County Historical Society.)

New York Store.

(Opposite the Miner's Exchange.)

Murphy's.

HAYNES & CO.,......Proprietors.

....DEALERS IN....

PROVISIONS,

GROCERIES,

Liquors, Hardware, Mining Tools, Crockery, Clothing, Boots, Shoes, &c., &c.

☞Goods Delivered Free of Charge.☜

UNION RESTAURANT.

THE undersigned beg leave to inform the citizens of Murphy's and surrounding camps, that having fited up the old stand, formerly occupied by Spencer & Webb, opposite the Post Office, they are prepared to furnish meals at all hours. of the very best quality, having made arrangements they will keep constantly on hand all the delicacies of the season, such as Game, Fish, Pastries and the Earliest Vegetables. Determined to please, they solicit a share of liberal patronage.

Board, per day,.................$ 2.00.
" " week,................ 10.00.
Beds, " night,..........50 cts & 1,00.

HARDWICK & LAPHAM.

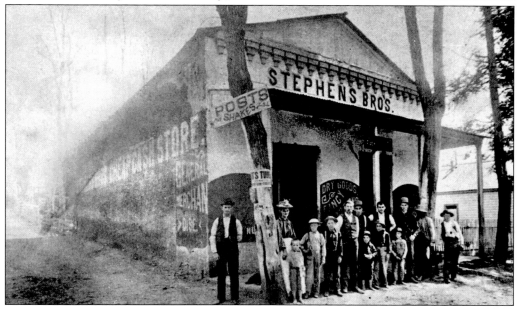

The Thorpe family operated a bakery business in this building in the 1890s, but the stone building now known as the Thorpe Bakery had its beginnings in 1862 as the tinshop and store of Louis Robinson. During the 1860s and early 1870s John Heinsdorff operated a store and bakery in the building; by 1872 Adam Majors had taken over the business. In 1882, John Langdon March purchased the property and operated a store. Horace Edson Thorpe then purchased the building and operated the store and bakery under his name, which is still etched on the glass. In the late 1950s, the building was saved by Isobelle Bishop Dibble, who purchased and rehabilitated it when it was slated for destruction. (Courtesy of Otheto Weston.)

At the west end of Main Street, Pierre Bonnet built his stone store in 1860 on the site of the "William Connell Bowling Alley Lot." The building was sold to Victorene and Eugene Compere in 1861, and occupied by them as a store for several decades. It was remodeled in 1939, and a second story was added. (Courtesy of the author.)

Genoese Italians were early-day merchants in all of the towns in the Southern Mines, and were well represented in Murphys. One of the first to rebuild after the fire of 1859 was Vassallo and a company of Italians who, in 1860, rebuilt their frame store with a stone fireproof grocery and provisions store. During the early 1860s, it was operated by Ruiseco and Orengo as a store and bakery, but by 1870 Dave Baratini and Paul Segale were operating their store in the building, with the Baratini blacksmith shop in a frame building to the east. In 1912, evidently on a hunting expedition, young Jim Segale posed with his dog and rifle. (Courtesy of Murphys Old Timers Museum.)

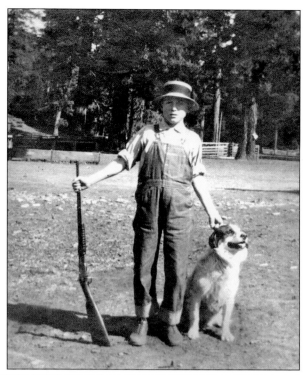

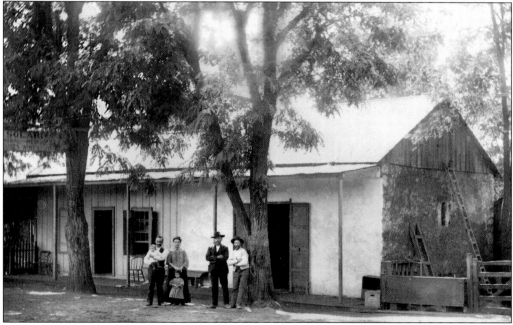

Easterly, on the south side of Main Street and now occupied by the office of the Union Public Utility District, in the late 1870s Bernardo Besso, called Stangetti, built a stone store where he sold cigars, liquors, and groceries. The building was later sold to Sebastian Solari, who added the wooden portion for his living quarters. (Courtesy of the Calaveras County Archives.)

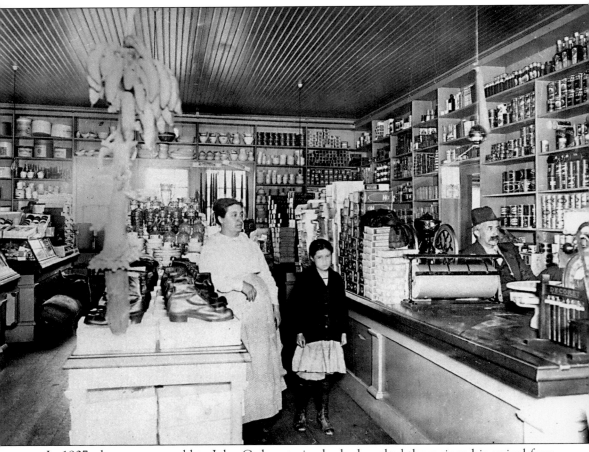

In 1907, the store was sold to John Cadematori, who had worked there since his arrival from Genoa in 1893. The Cadematori family is pictured inside their store, which sold everything from bananas to high-topped shoes. (Courtesy of the Calaveras County Archives.)

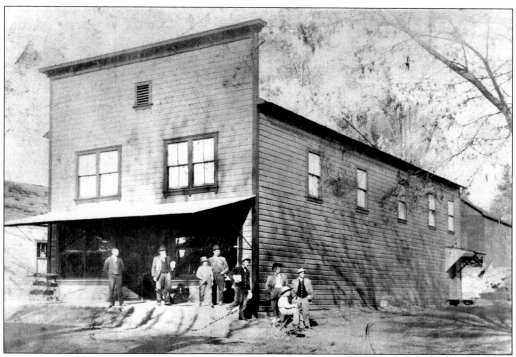

The Stephens brothers maintained general stores in Murphys and Sheep Ranch for many years, occupying several buildings during their tenure in Murphys. They first held forth in the Traver Store, then Dr. Jones Apothecary, and, finally, in what became known as the Murphys Central Market, later operated by the Riedel family. The frame building, originally the Hendsch Hotel on Big Trees Road, was moved to the site after the block was destroyed in the 1893 conflagration at the Matteson and Garland Livery Stable. (Courtesy of the Calaveras County Archives.)

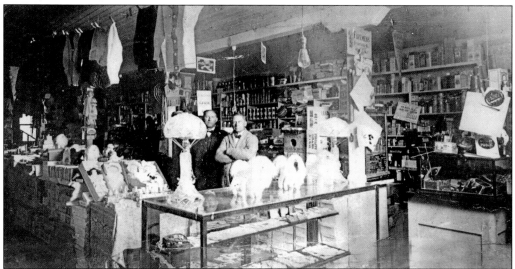

The Stephens brothers, Jim and Ben, are pictured with their stock-in-trade in the early 1900s. (Courtesy of the Calaveras County Archives.)

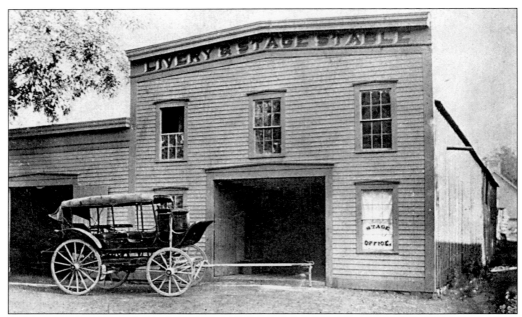

The most important livery stable in town was that of T.J. Matteson, who in the early 1850s began the operation of a stage line to Angels Camp by way of Six Mile Creek. His first stable burned in the 1859 fire, but was rebuilt soon thereafter. After the railroad was constructed from Stockton to Milton, Matteson ran four-horse stages not only to Murphys and the Big Trees, but to Yosemite as well. This photograph of the stable, with one of their stages, was taken in the 1880s, when Matteson was in partnership with Charles Garland. The building burned in 1893 and in 1895 Matteson sold the line to the Raggio brothers, who continued to operate it until the Sierra Railroad reached Angels Camp from Jamestown in 1900. (Courtesy of the Calaveras County Historical Society.)

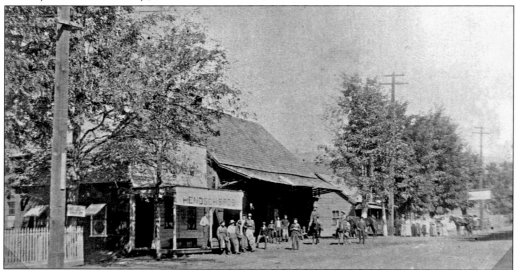

In the early 1900s, the Hendsch Brothers Blacksmith shop, one of many such establishments, was located on the corner of Main Street and Big Trees Road. (Courtesy of the Calaveras County Historical Society.)

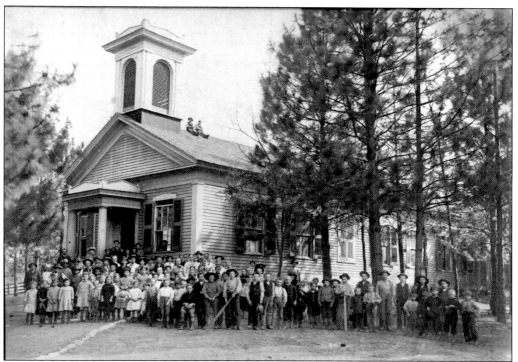

In 1855, by the time the first public school was established on the site of the present Masonic Hall, three private schools had already opened in Murphys. The public two-room school, known as "Pine Tree Cottage," was built in 1860 in the popular Greek Revival style of the day, and served the community until the 1960s. (Courtesy of Murphys Old Timers Museum.)

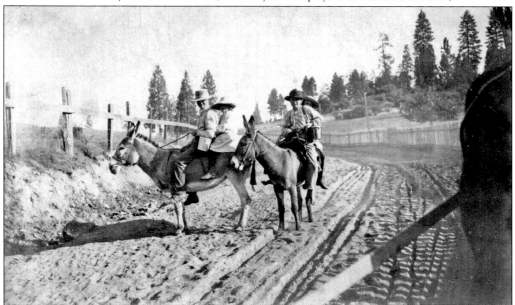

Around the turn of the 19th century, this was the preferred method of transportation to school. (Courtesy of the author.)

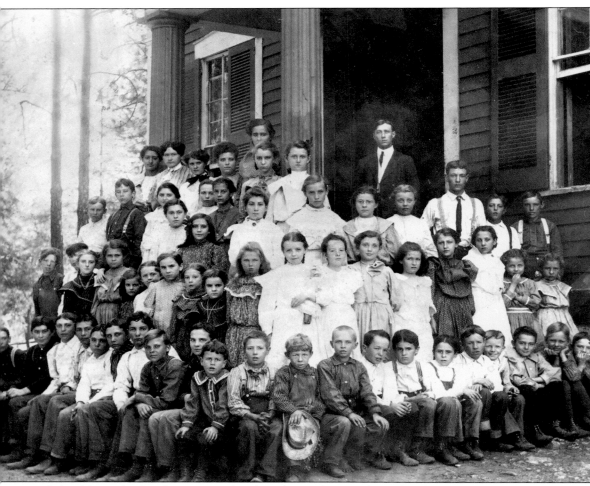

John Alexander Smith, a principal and teacher at the Murphys School from 1904 to 1906, later became a Calaveras County judge and the founder of the Calaveras County Historical Society. He is pictured here with his assistants Mary Mulgrew and G.B. Wilson and the class of 1906. (Courtesy of the Calaveras County Historical Society.)

The present elementary school was named for Albert Michelson, the first American to win the Nobel Prize, who attended school in Murphys as a boy. He went on to earn his Ph.D. in physics, and while working at the U.S. Naval Academy in Annapolis, measured the speed of light, for which he received his prestigious prize. In later years, Albert Einstein stated that he based his theory of relativity on Michelson's work. (Courtesy of Wally Motloch.)

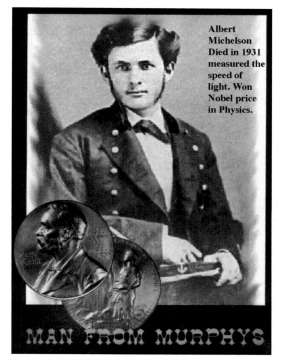

Albert Michelson Died in 1931 measured the speed of light. Won Nobel price in Physics.

MAN FROM MURPHYS

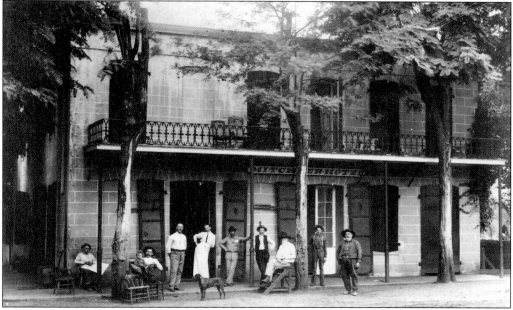

The Miner's Exchange was the first hotel in town, a three-story structure built by Philip Birmingham. J.L. Sperry and John Perry purchased it and rebuilt it with fireproof stone after the fire of 1854. Sperry operated the hotel until 1876. In 1882, the Mitchler family bought it, continuing to operate it until 1945. Although several boardinghouses were located in Murphys, no hostelry ever rivaled the prominence of the Murphys Hotel. (Courtesy of the Calaveras County Archives.)

Religion came early to Murphys. The first Catholic church was constructed in 1855, and the first Protestant church in 1853. The original Catholic church was replaced by the brick St. Patrick's Catholic Church, dedicated by Archbishop Alemany in 1861. The property was donated by Dr. Jones, and was reputedly built by miners who wanted to mine the original church property located on the creek. (Courtesy of Murphys Old Timers Museum.)

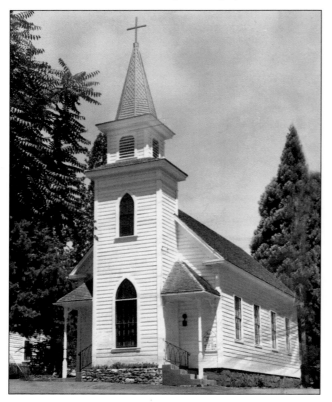

In 1853, a Methodist church was built in Murphys, but was soon taken over by the Congregational Church, organized in 1866. In 1895, the new white-frame First Congregational Church was dedicated, on the site of the earlier, small-frame church (Courtesy of Murphys Old Timers Museum.)

Dr. Richard Coke Wood, professor of history at the University of the Pacific in Stockton, was a longtime resident of Murphys and founder of its museum. He is pictured here with Al Gross and Eva Stephens, to his left. (Courtesy of Murphys Old Timers Museum.)

Murphys had its share of fraternal organizations. The Masonic Lodge and Independent Order of Odd Fellows was organized in 1852 and 1858, respectively; both constructed the present lodge buildings in 1902. The original Native Sons of the Golden West Hall was built by the Independent Order of Good Templars, a group of teetolars associated with the Methodist Church, in 1881. Two years later, the building was sold to the Murphys Literary and Dramatic Society, who had been associated with the group since at least 1868. It was deeded it to the Chispa Parlour, Native Sons of the Golden West, in 1916, and they remodeled it and added the clipped gable. It burned in the 1990s and was rebuilt on the original location. A group of young thespians also used the building. (Courtesy of Murphys Old Timers Museum.)

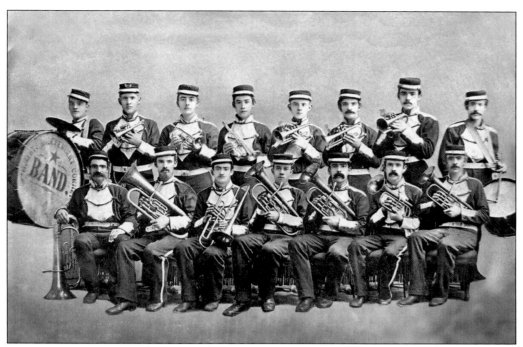

Murphys had its share of bands, including a women's band and the Murphys Cornet Band, pictured in the late 1890s. (Courtesy of Murphys Old Timers Museum.)

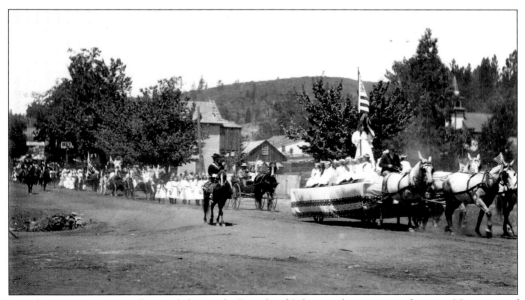

Parades were quite popular, and this early Fourth of July parade was one of many. (Courtesy of Murphys Old Timers Museum.)

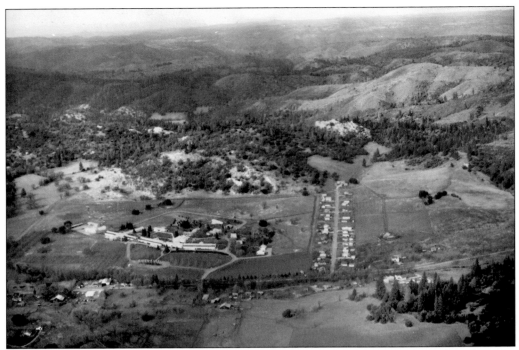

In 1925, the County of San Joaquin was trying to find a location for a sanatorium for tubercular patients. Land was purchased from John Hauslet that same year, and by 1927 the complex was completed. The facility cared for tuberculosis patients for 20 years, later becoming the San Joaquin County Hospital. The extensive buildings and grounds of the Bret Harte Sanatorium are shown in this aerial view, with Williams Street to the right. (Courtesy of the Calaveras County Historical Society.)

Murphys today is made up of wood, brick, and stone buildings dating from the 1850s to the present. Along Main, Church, Algiers, Jones, Scott Streets, and Sheep Ranch Road, many historic structures remain, including commercial buildings with neoclassical proportions: pediment roofs and raking and dentil cornices. The wooden commercial buildings are of frame construction with horizontal board siding and gable roofs. Some are Italianate Commercial from the 1860s, while those dating from the 1880s through the early 1900s have traditional Western-style false fronts, recessed doorways, and storefront windows. (Courtesy of the Calaveras County Historical Society.)

A step up from the tents of the original miners were the single-walled cabins of board-and-batten construction, usually with a stone chimney mortared with mud to provide heat and a place to cook family meals. (Courtesy of the Calaveras County Historical Society, No. 6-38.)

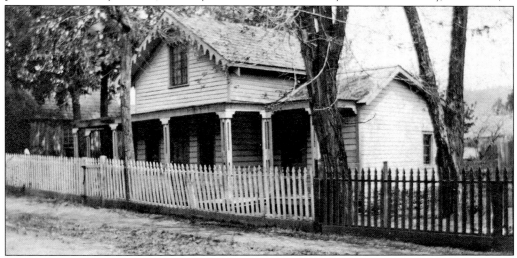

Early residences, several of which predate 1854 assessment records, were of frame construction; vernacular examples of higher architectural styles found in the eastern United States. They included simple neoclassical, Gothic revival, and Italianate buildings with horizontal board siding, gable or hipped roofs, and stone foundations. Fenestration consisted of wood frame windows, six-over-six lights, double-hung. Doors were centrally located on the primary facades and were of wood, with four recessed panels. Most of the residences had porches, full-width across the facade, and often wrapping around one or both side elevations. On Algiers Street, the c. 1860 home built by Charles Hunt, was occupied by local principal and schoolteacher Enos Floyd from the late 1870s to the 1920s. This photograph was taken by a member of the Fisk family in the early 1900s. (Courtesy of the Calaveras County Historical Society.)

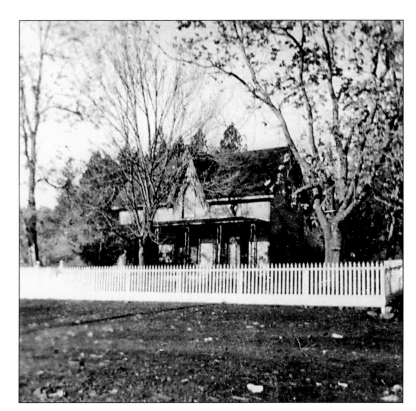

Alexander Putney built his Gothic Revival home in 1857, a mansion in its day, and befitting his position as a judge. It was purchased by the Sperry family in the 1860s and occupied by them for many years. (Courtesy of the Calaveras County Historical Society.)

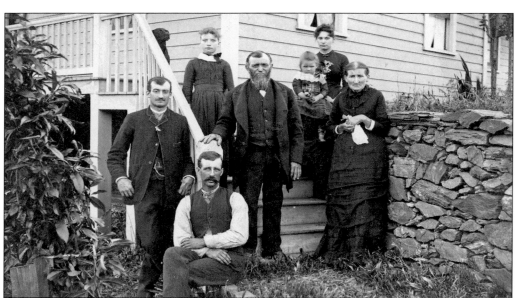

John and Eva Maria Heinsdorff, their children Joseph, Katie, and Mary, with granddaughter Hattie Jenkins and her father, William, posed proudly on the steps of their new home on the Murphys Toll Road, which was destroyed by fire soon thereafter. (Courtesy of the Calaveras County Archives.)

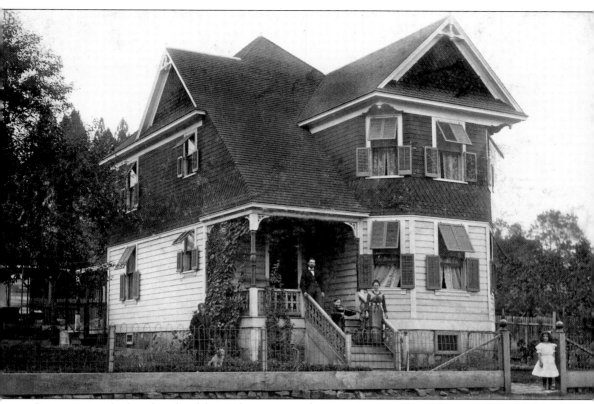

Beginning in the last decade of the 19th century and continuing into the early years of the 20th, simple one- and two-story Queen Anne residences, with their asymmetrical facades, decorative shingles, and spindlework, began to make their appearance. Many of these were constructed by merchants as homes more befitting their established and profitable positions in the community. The home of Jim Stephens, built on Main Street in 1900, was one of the more prominent ones. (Courtesy of the Calaveras County Archives.)

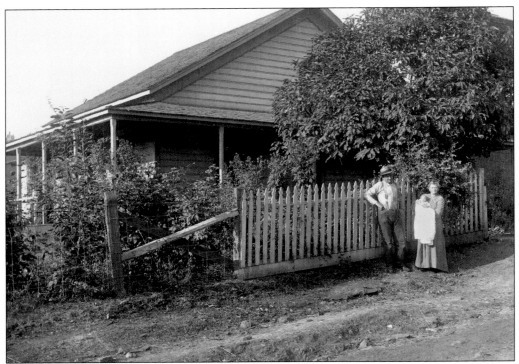

At the junction of French Gulch Road and the Murphys Toll Road, Mr. and Mrs. Heinsdorff and baby Joe stand by their picket fence shortly after Joe's birth in 1905. (Courtesy of the Calaveras County Archives.)

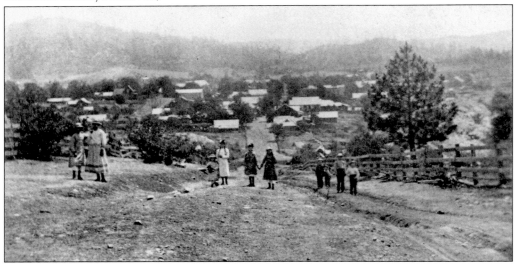

Barns were also associated with many of the original residences in the community, as families kept a dairy cow or two, some sheep, a hog, and chickens. Orchards and vines were planted and vegetable gardens established, enabling most families to be relatively self-sufficient. By the early 1900s, when these children walked to town from French Gulch, Murphys was described by a New York writer as a somewhat deserted mining town, but obviously a bucolic paradise. (Courtesy of Murphys Old Timers Museum.)

Seven

AGRICULTURE, LIVESTOCK, AND LOGGING

Following the decline of placer mining in the Mother Lode after 1860, ranching became more important to the foothill economy. Local farming never developed much beyond a subsistence level and gradually gave way to livestock operations. As the mining economy declined, however, farming gained importance as a family enterprise which helped to establish more permanence and stability in the society. Truck gardens were established, mostly by Italians, and produce was delivered to the towns and outlying communities by wagon.

Many settlers in the Murphys area planted orchards, especially apples and other fruits, while others planted grapes and developed family wineries. By 1851, about two miles north of Murphys on San Domingo Creek, Benjamin Inks had established a vineyard, the present location of the Stevenot Winery. A member of the Shaw family, who purchased the ranch in the 1880s, stands in the foreground with the house, barn, blacksmith shop, and gardens behind. (Courtesy of Barden Stevenot.)

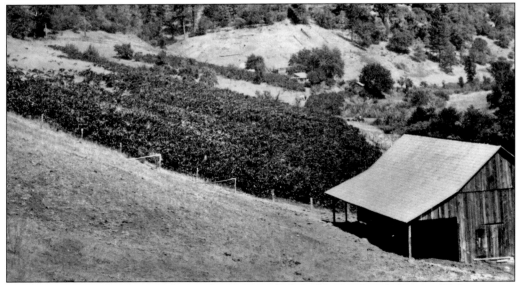

Others who planted vineyards in the area included the family of George Hahn, across Sheep Ranch Road from the Stevenot Winery, maintained by the Vogliotti family after they purchased the ranch in the early 1900s. In later years, the family turned to truck farming, supplying the communities of Murphys and Sheep Ranch with vegetables. (Courtesy of the Calaveras County Archives.)

Beekeeping also appeared to be a local industry, depicted in a photograph taken by a member of the Fisk family around the turn of the 19th century. (Courtesy of the Calaveras County Historical Society.)

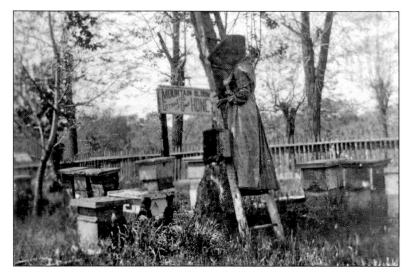

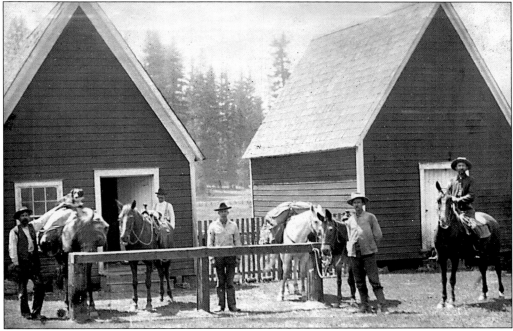

Many families in the Murphys area raised at least some livestock, including milk cows, stock cattle, hogs, sheep, goats, and chickens for family consumption. A few, however, made their livelihood by establishing cattle and sheep ranches, selling to butcher shops, and later driving their stock to the railhead at Milton for transportation to distant markets. Transhumance was an important historic land use. As early as 1850, there were accounts of stock grazing in the high country, where the ranchers from the foothills drove their stock every June or July so that animals could partake of the verdant mountain pastures. This cycle was extremely important, as the green grass of the lower elevations would have been eaten and the stock ponds would be dry by mid-summer. This pattern of high country stock grazing has continued to the present, although in greatly reduced numbers. Here, a group of cattlemen saddle up at Blood's Meadow. (Courtesy of the Calaveras County Archives.)

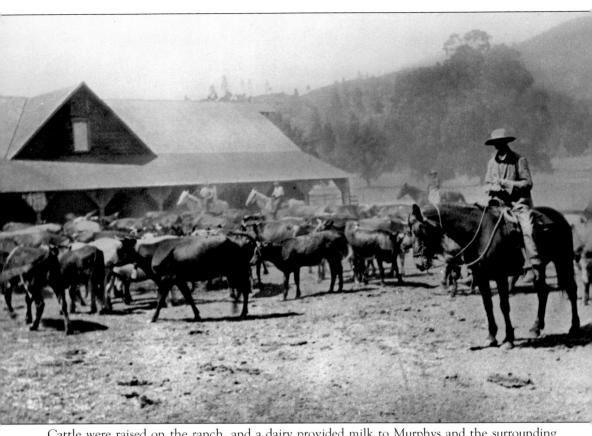

Cattle were raised on the ranch, and a dairy provided milk to Murphys and the surrounding area. (Courtesy of the author.)

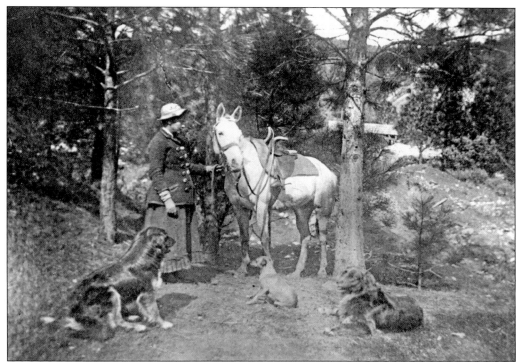

One of the more important ranches in Murphys was that of Ethel Willard Adams, the daughter of Zabdiel Adams Willard and Lucy Allen Ware Willard, located on Pennsylvania Gulch Road. In the mid-1880s, Mrs. Adams was photographed at her father's Oro y Plata mine with her horse and dogs. (Courtesy of the author.)

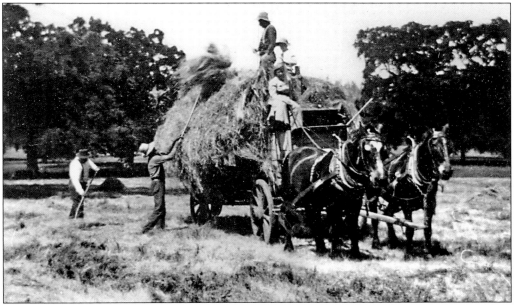

Hay and alfalfa were grown on the surrounding fields to feed the cows and cattle during the winter months. (Courtesy of the author.)

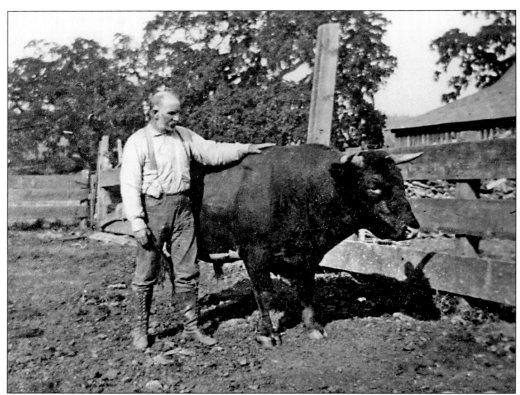

George Hinkston, the Adams Ranch foreman, admires one of his bulls. (Courtesy of the Calaveras County Historical Society.)

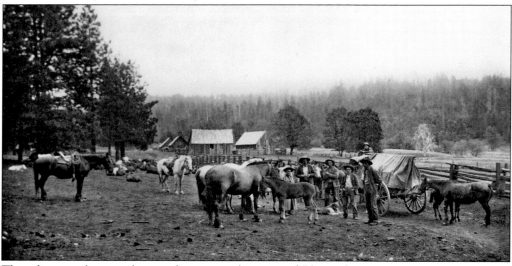

This photograph was taken at the present location of Blue Lake Springs, on the way to the summer range at Adams Camp on Disaster Creek, below Highland Lakes. Inscribed on the back is the following: "Lunch at Moran's Ranch, June 1912. 'Z-1' Outfit: Mrs. Adams, George Hinkston, Fred Pool, Willie Pillsbury, Will Gotica, Bob Richardson, Anthony on wagon." (Courtesy of the author.)

After the death of Mrs. Adams in 1927, foreman Fred Kenney inherited the ranch and operated the Table Mountain Dairy there for several years. In this photograph, Fred is standing on Main Street with several of his young friends. (Courtesy of the author.)

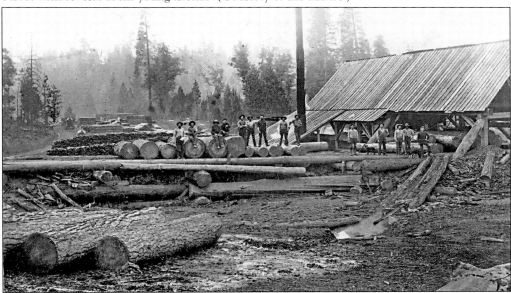

Mining drove the development of the logging industry in Calaveras County. Millions of board feet of lumber were needed for the miles of flumes required to convey the waters from the rivers and streams to the placer mining areas, and many more were required for timbering the underground mines. As the towns developed, lumber was also needed for the construction of the houses and commercial enterprises. Sawmills were established in Murphys in the earliest years of the Gold Rush. Early mills in town were operated by Hanford, Gilman & Co., and others. One of the earliest mills was constructed by the Union Water Company to provide lumber for its flumes. Soon, other mills were in operation to provide timbers for the mines, and lumber for houses and buildings. (Courtesy of the Calaveras County Archives.)

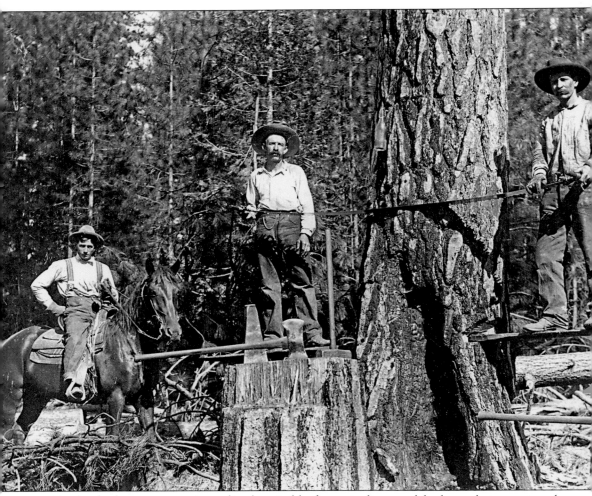

The lands that were not immediately suitable for agriculture and had no obvious mineral reserves were ignored for the first three decades after the gold discovery. In 1878, however, Congress passed the Timber and Stone Act, allowing the individual acquisition of 160-acre parcels of timbered land for $2.50 per acre. Speculators regularly made agreements with potential patentees and assembled substantial adjacent blocks of prime, virgin groves of timber to be made available to sawmill interests. In this early photograph, Robert Haddock and Henry Lytle were using the standard tree-felling method of the day: standing on boards driven into the tree to support them while they sawed through a smaller circumference of the tree than the stump. This view was taken near McKay's sawmill on Love Creek in 1885 or 1890. (Courtesy of the Calaveras County Archives.)

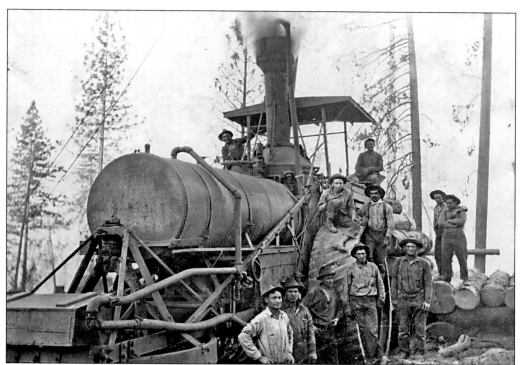

In the higher elevations, vast tracts of land were acquired in this way, allowing the growth of a new industry in a region once dependent upon mining. Beginning in the 1890s and continuing through the 1940s, logging became a significant local industry in many mid-elevation areas. A company town was established at White Pines, while Avery expanded with the increased population and prosperity. Logging continues in the forests today, but no sawmills remain. The timber is trucked to Tuolumne or more distant locations for milling. In this photograph, John McKay stands behind his donkey engine, used for hauling logs down the steep hillsides to the loading deck. One of the Indian Hodge brothers stands sixth from the left. (Courtesy of the Calaveras County Archives.)

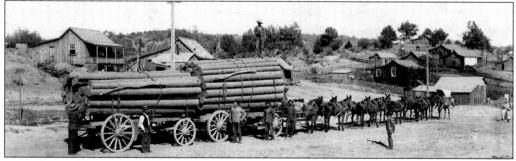

Several Murphys families were involved in the lumber business from the earliest years, with extensive timber operations in the high county and lumberyards in town. The site of the Dickenson/Kimball and Cutting lumberyard was located on the northwest corner of Main Street and Big Trees Road. The mill of A. Sleeper, later operated by Willis Dunbar, was located in present Arnold, with a lumberyard in Murphys west of the Dunbar House on Jones Street. In this view, 70 logs are being hauled by teams on two wagons through the streets of Murphys. (Courtesy of the Calaveras County Archives.)

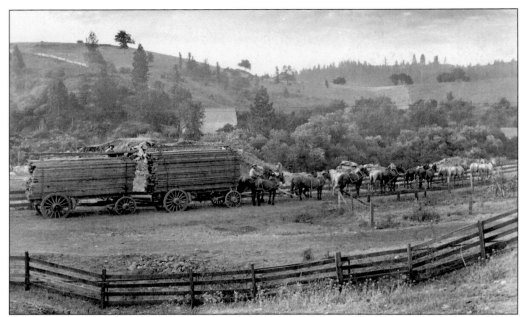

An equal number of wagons and teams were required to transport the milled lumber to Angels Camp. (Courtesy of the Calaveras County Archives.)

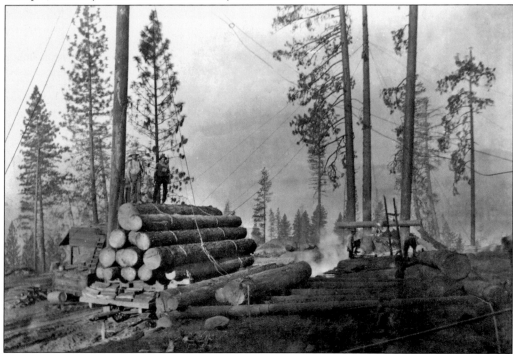

The logging industry really came into its own during the 1880s and 1890s, when lumber was transported outside of Murphys and Angels Camp. After the logs were hauled to the loading deck, they were piled on wagons with steel tires for transportation to the mill. (Courtesy of the Calaveras County Archives.)

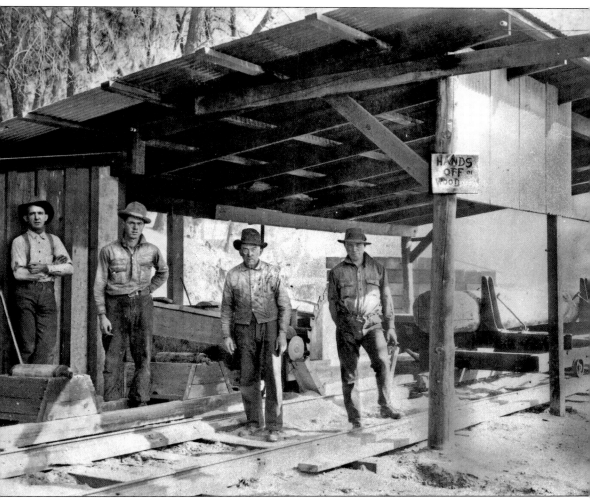

Many of the local Native American men, including the Hunters, Shrums, Sheltons, Wilsons, and Hodges, were employed by the logging companies. In this view, Charles Shelton and several unidentified men are depicted at a mill in the Avery area. (Courtesy of the Calaveras County Archives.)

In 1883, Willis Dunbar sold his lumber operations to John Manuel, who operated a mill at present White Pines Lake. The Manual lumber yard and residence were located in Murphys on the northeast corner of Church and Main streets. This photograph of the company office was taken in the late 1880s. (Courtesy of the Murphys Old Timers Museum.)

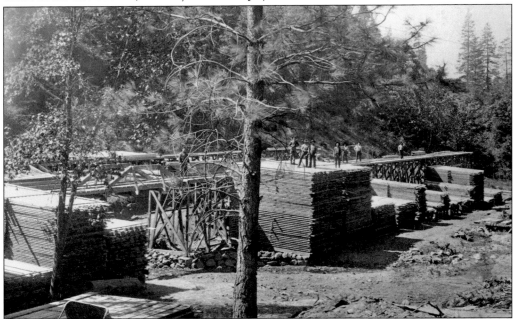

Beginning in the 1890s, one of the most important local mills was operated by the Raggio family in San Domingo Canyon, with a lumberyard on the hillside north of Highway 4 above Murphys. (Courtesy of the Calaveras County Archives.)

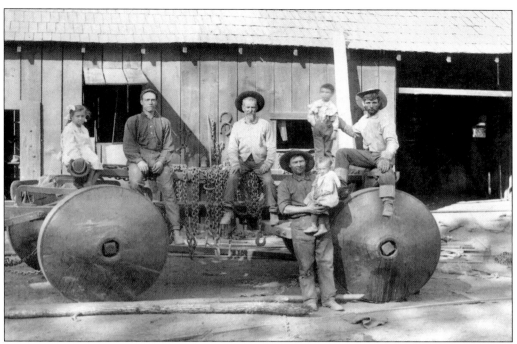

This view of the blacksmith shop was taken in 1903, with Velma Raggio, Alfred Metz, Louis Ashley, Ernest Raggio, Emil Lombardi, Matt Christiansen, and Earl Raggio posing for the photographer. (Courtesy of the Calaveras County Archives.)

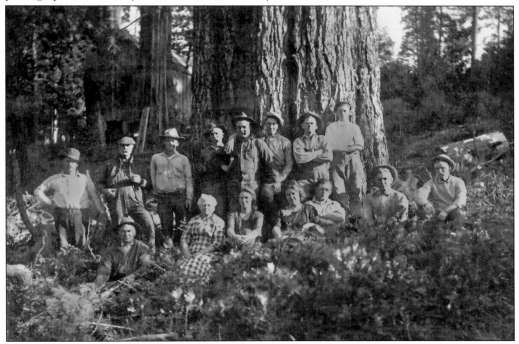

This photograph of the crew at the Raggio Mill above Murphys was taken in May of 1923. (Courtesy of the Calaveras County Archives.)

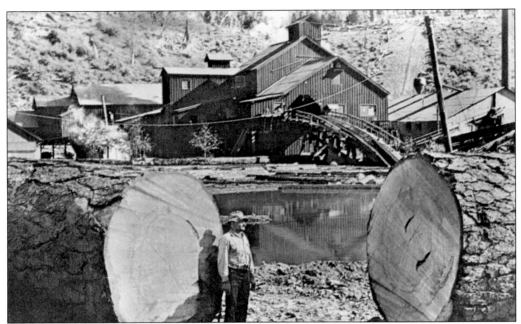

In 1939, the Blagen Lumber Company built a new mill at present White Pines Lake near Arnold. A modernized operation, the enterprise was first a family business. The Blagens established a company town, named White Pines, near their mill. The company ran two shifts of men, producing a great amount of lumber during World War II, and employed more than one hundred men. During this period, the mill was taken over by American Forest Products, but kept the Blagen name. The mill flourished for many years, but then waned in production, leading to its closure in 1962. (Courtesy of the Calaveras County Historical Society.)

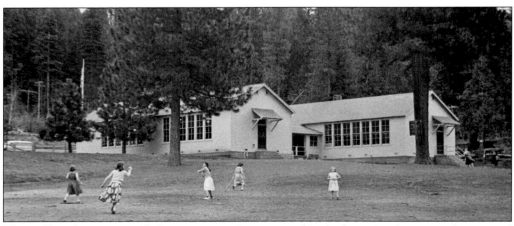

The mill and town provided permanence in an area that had previously seen only seasonal occupation. An outgrowth of this was the establishment of the first school in the area. (Courtesy of the Calaveras County Archives.)

Eight

SCENES OF WONDER AND CURIOSITY

In 1852, a hunter for the Union Water Company "discovered" the Calaveras Big Trees. Although the trees had been noticed by John Bidwell in 1841 and by other emigrants in 1849, it was Augustus T. Dowd who received credit for their discovery. As noted by chronicler James Mason Hutchings in 1859:

> *Murphys Camp, which until then had been known as an obscure, though excellent, mining district, was lifted into notoriety by its proximity to, and the starting point for, the Big Tree Grove, and consequently was the center of considerable attraction to visitors.*

Thus began the role Murphys was to play as the tourism center for visitors to the Calaveras Big Trees, Mercer's Caverns, Moaning Caves, Natural Bridges, San Antonio Falls, and other natural wonders of the region. Among the recorded visitors who came to see the sights were the illustrious writers Mark Twain and Bret Harte, who used Murphys as the locale for some of their stories; James Mason Hutchings, who wrote glowing accounts in his magazines read by thousands; and other well known personages including Horatio Alger, Ulysses S. Grant, Henry Ward Beecher, John Bidwell, and others too numerous to mention.

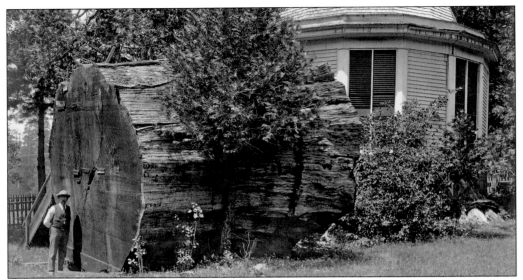

Dowd's discovery created tremendous excitement throughout California and the rest of the United States. In the spring of 1853, Capt. William H. Hanford, president of the Union Water Company, envisioned a way to make a fortune by stripping the bark off the "Big Tree" and sending it on tour to New York and Europe. The tree was felled using pump augers and chisels, as no saw was large enough for the project. The Big Tree stump was planed smooth, and dancing on it became a popular activity for the grove, as did concerts, lectures, weddings, and other functions. (Courtesy of the Calaveras County Archives.)

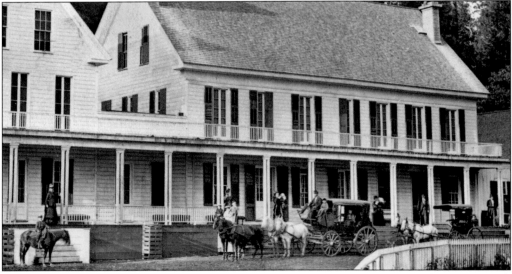

In the summer of 1861, James L. Sperry and John Perry constructed the Mammoth Grove Hotel, which could accommodate 60 lodgers, some 600 yards northwest of "the Big Stump." Edward Vischer wrote in 1862, "A spacious structure has replaced the original Big Tree Cottage; the foreground of the hotel was to have been laid out as a park, the ornamental shrubbery of which would have formed a striking contrast to the giant proportions beyond." Hundreds of trees had to be cut down "to let in a little sunlight." This photo was taken in the 1870s, during the hotel's heyday. (Courtesy of the Calaveras County Historical Society.)

In such demand were trips to the Big Tree, that Ralph Lemue of Angels Camp built a special stage to carry visitors. (Courtesy of the Calaveras County Historical Society.)

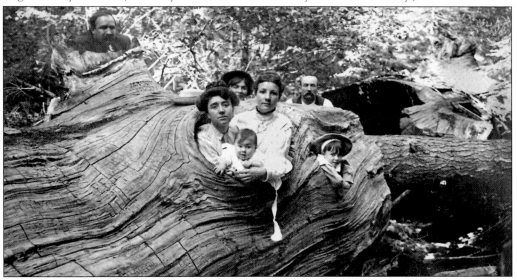

During the 1880s and 1890s, the popularity of the giant sequoias at Big Trees declined, as other groves, especially the Mariposa Grove on the Yosemite Road, attracted more visitors. In 1900, in declining health, Sperry sold the Mammoth Grove Hotel and the 3,200 acres of land to Robert Whiteside, a lumberman from Duluth, Minnesota. Shortly thereafter, upon learning that the grove was sold to a lumberman, a public outcry was made and a campaign started to establish a state or national park that would protect the Calaveras Groves, an action that was not fulfilled for over 50 years. For the next 31 years, until it was sold to the State of California, Mr. and Mrs. Job Whiteside operated the hotel. During their tenure the Big Trees experienced an unprecedented amount of visitors and the photographers who captured them in various poses in, under, and around the giants. Especially popular was one of the fallen trees, where groups of people stuck their torsos through the knot. (Courtesy of the Calaveras County Archives.)

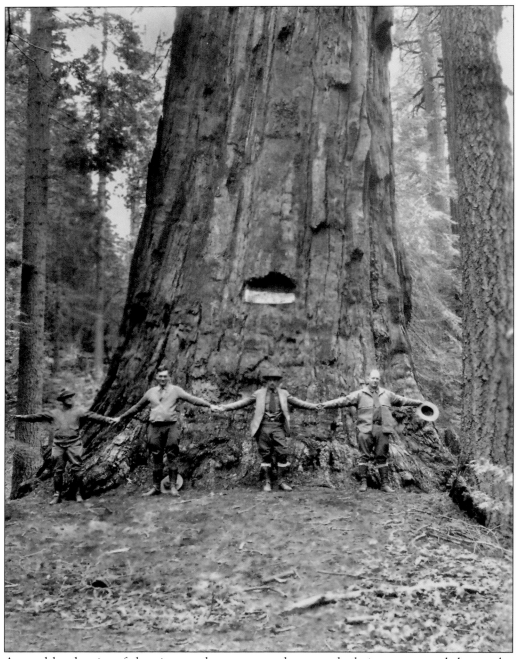

Amazed by the size of the giants, others attempted to stretch their arms around the trunks. (Courtesy of the Calaveras County Archives.)

Horses were driven through the trees. (Courtesy of Wally Motloch.)

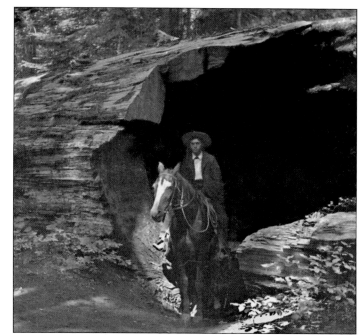

Gigantic tree trunks have always been a fact of life around Murphys. Here, a group poses on "Eagle's Wings." (Courtesy of the Calaveras County Archives.)

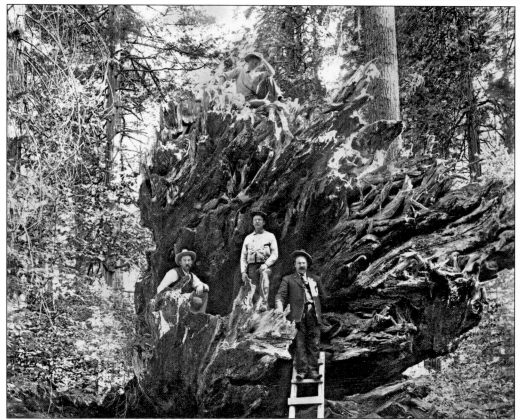

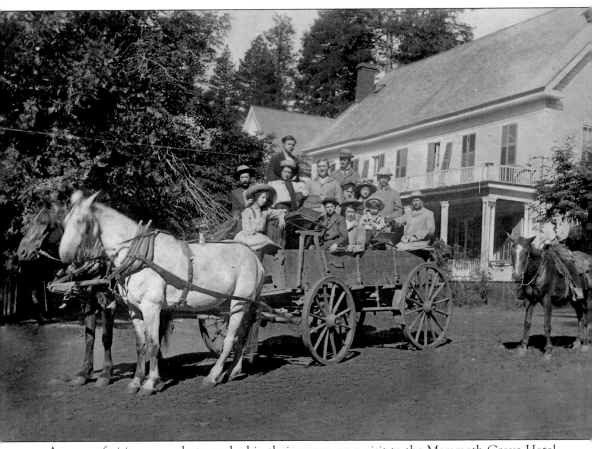

A group of visitors was photographed in their wagon on a visit to the Mammoth Grove Hotel around the turn of the 19th century. (Courtesy of the Calaveras County Archives.)

Tents were set up under the mighty giants for the convenience of visitors. (Courtesy of the Calaveras County Archives.)

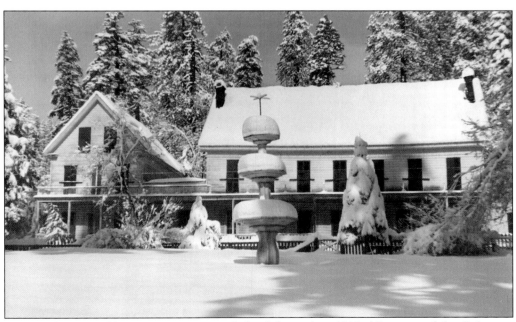

The hotel, pictured here in a winter wonderland, burned in 1943. (Courtesy of the Calaveras County Archives.)

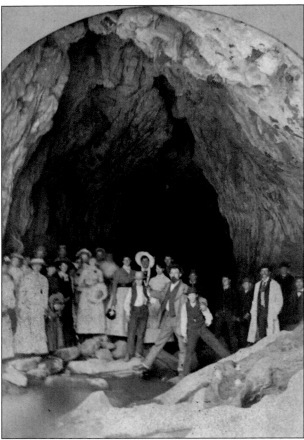

As Murphys was located in a limestone belt, numerous caves and caverns had been formed in the Paleozoic era, several of which were so impressive that they were opened to the public and became paying operations for their owners. Below Vallecito, Coyote Creek flowed through the Natural Bridges, where water eroded the limestone, creating caverns with impressive stalactites and stalagmites. This view of the lower side of the Upper Bridge was taken around the turn of the 19th century. (Courtesy of Wally Motloch.)

The Natural Bridges were a popular tourist destination, and these visitors posed at the upper side of the Upper Bridge, where balls and picnics were held under the high arches. (Courtesy of Wally Motloch.)

For many years, the Natural Bridges were owned by L.A. "Bach" Barnes, who built a cabin on Coyote Creek and catered to visitors. Old Bach enjoyed having his picture taken and often dressed up and led tours of the caves, even traveling to the State Fair to advertise its wonders. (Courtesy of the Calaveras County Historical Society.)

In 1902, a group of visitors posed in their wagon during a trip to the Natural Bridges, where a wagon trail was constructed part way down the hillside. (Courtesy of the Calaveras County Historical Society.)

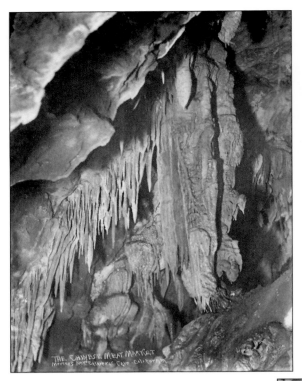

Mercer Caverns, "discovered" by Walter Mercer in 1885, had initially been explored by Leonard W. Noyes in 1857, while he was prospecting on the ridge between Owlsburrow and San Domingo. Noyes, however, was too interested in finding gold to publicize his find. The caverns were operated commercially for many years by the Mercer family, who sold tickets at their home on the northwest corner of Church and Main Streets and led tours of the popular attraction. One of the formations is shows in this view. (Courtesy of the Calaveras County Archives.)

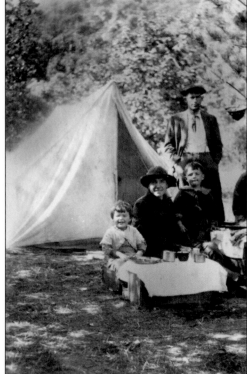

Although many came to view the impressive natural wonders, still others simply wished to enjoy the cool summers in the high country, as did this family in the 1910s. (Courtesy of the Calaveras County Archives.)

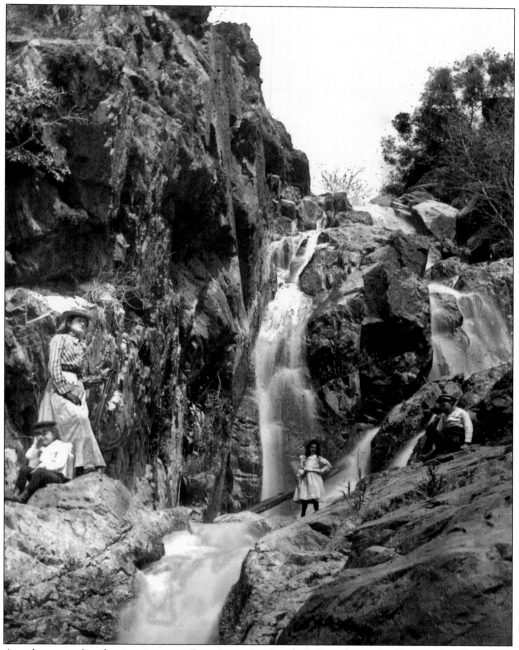

Another popular destination was San Antonio Creek Falls, where the Burson family built a cabin and catered to tourists who made the rough trek to the base of the falls, shown here about 1900. (Courtesy of the Calaveras County Archives.)

This group of skiers was enjoyed the winter attractions at the Big Trees, a precursor of the activity to come at the Bear Valley Ski Area. (Courtesy of the Murphys Old Timers Museum.)

Nine

OUTLYING COMMUNITIES

By the 1860s, Murphys had evolved from a mining community to a center for tourism and as a supply center for the outlying communities and mining areas. These included Douglas Flat, about one and one-half miles south; Collierville, about four and one-half miles east on Table Mountain; Sheep Ranch, nine miles north; the waystations on Ebbetts Pass, and several smaller encampments of miners and settlers such as Brownsville, San Domingo, and others.

Gold was discovered on Douglas Flat, named for one of three miners who worked in the diggings in the early years, and soon became a haven for miners from Wales and Italy. Placer gold was first found on the banks of Coyote Creek, and then tunnel companies were organized to tap the riches in the Tertiary gravels beneath Table Mountain. The creek was mined by placering, hydraulicking , and later dredging, totally obliterating its original channel. Hydraulic monitors washed the earth from the gravels on the hillside, finally filling the flat with so much debris that the mines were shut down.

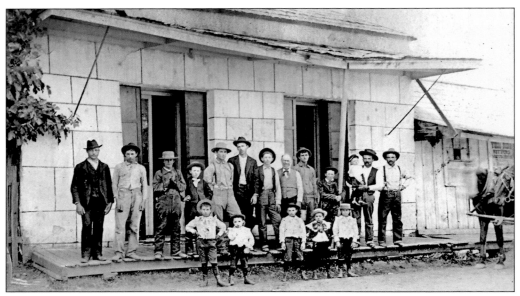

As mining activity waned, fruit growing became the primary industry. The Gilleado/Gagliardo Store, built of local limestone faced with plaster, opened in 1861. It was later owned by the Malespina family, who leased space to Wells Fargo & Co. A group of townsfolk posed on the front porch for this 1898 photo. (Courtesy of the Calaveras County Archives.)

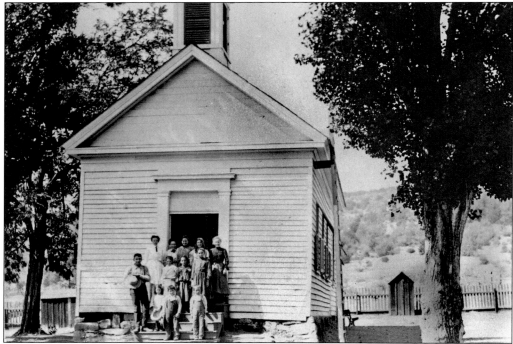

The oldest extant school in Calaveras County, the Douglas Flat school, reputedly built in 1854 as a church, was converted to meet the educational needs of the growing community. The teacher and pupils posed on the front steps for this early 1900s photo. (Courtesy of the Calaveras County Historical Society.)

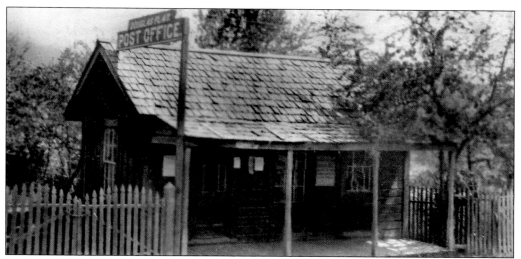

During the 1940s, this cabin was used as the Douglas Flat post office. (Courtesy of the Calaveras County Historical Society.)

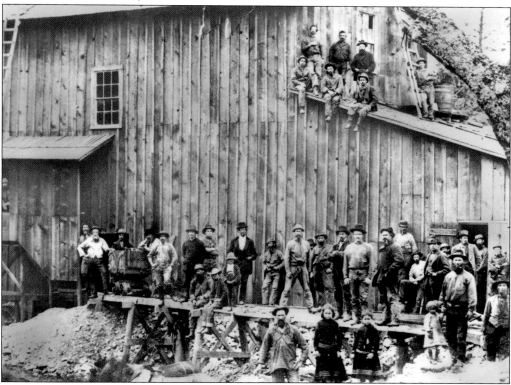

By far, the most important mining community near Murphys was Sheep Ranch, where gold was discovered on C.V. McNair's sheep ranch by Harvey Childers in 1867. First named Copperhead Flat because so many of the miners were from the south, the name soon reverted to Sheep Ranch. The mine became the most productive on the East Belt of the Mother Lode, and operated sporadically until the early 1940s. In this early view, the miners and their children posed at the mill. (Courtesy of the author.)

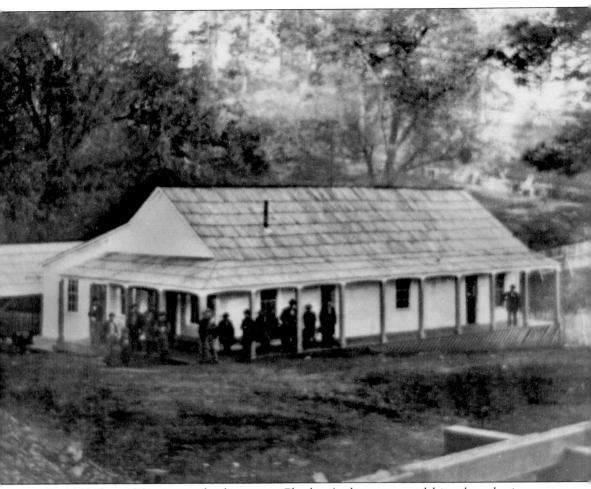

In 1868, Jonas Mauritson, also known as Charles Anderson, moved his saloon business, as well as lumber gleaned from the buildings, from Chee Chee Flat near Mountain Ranch to the community. By 1869, he was operating a saloon and public hall on the property. (Courtesy of the Calaveras County Historical Society.)

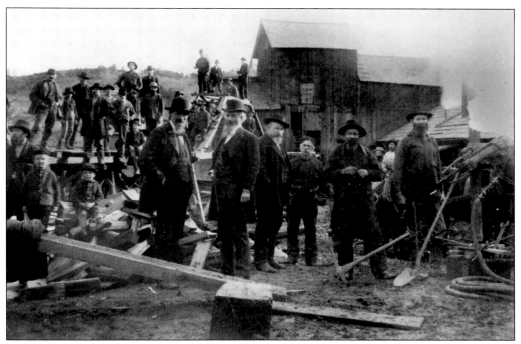

Beginning in 1877 and continuing through the 1880s, most of the individual mining claims were purchased and consolidated by Sen. George Hearst (father of William Randolph Hearst), William Tevis, and Ben Ali Haggin. The syndicate, which owned many of the major gold mines in the United States at the time, continued to operate the mine until 1893, after the death of Hearst. In this 1880s photograph, mine superintendent George Clary, George Hearst, and miners Harry and John Champion stand in the foreground with other miners and the mill in the background. (Courtesy of the Calaveras County Historical Society.)

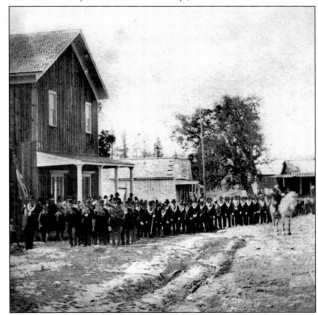

At the height of the boom in the 1880s, the town boasted a population of over 800 people, with stores, liveries, blacksmiths, three hotels, boardinghouses, saloons, and an IOOF lodge. On the Fourth of July 1881, the occasion of their 62nd anniversary, the Odd Fellows and their band lined up before their lodge on Center Street. The lodge building was later operated by the Poe family as the Eagle Hotel. (Courtesy of the Calaveras County Archives.)

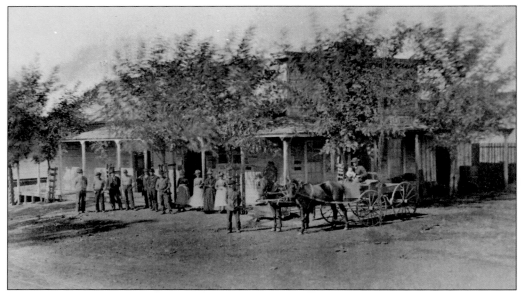

The first store in town, that of Arnold Freidberger and his son Leo, was located on the corner of Main and Oak Streets. In 1889 James Stephens, in the wagon with his son Ray, and a group of townspeople turned out for a photograph in front of the store. (Courtesy of the Calaveras County Archives.)

A few years later, Milton Stephens and his sons Benjamin and James opened their Stephens Bros. Cheap Cash Store and blacksmith shop on the adjoining property. This photo was taken in 1916, after the original store had burned and been rebuilt. (Courtesy of the Calaveras County Historical Society.)

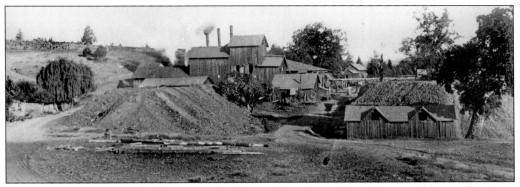

This view of the Sheep Ranch mine and mill was taken during Hearst's ownership. At this time, the buildings were of frame construction, with vertical board and batten siding, while the waste rock from the mill was piling up on all sides, and tailings were carried further away. (Courtesy of the author.)

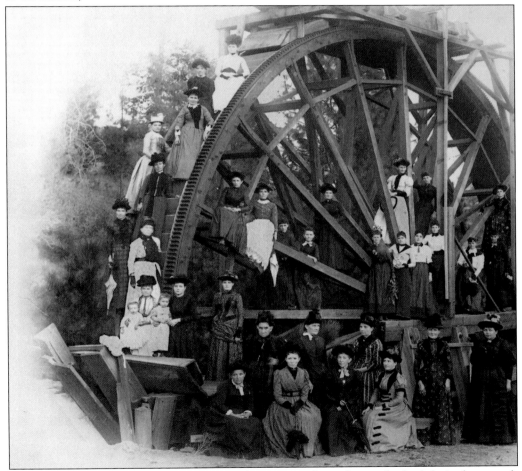

The wives and daughters of the Sheep Ranch miners and merchants also had their photograph taken in the 1880s, decorating the water wheel at the Chevanne Mine. (Courtesy of the Calaveras County Archives.)

Hub Ide, the operator of the Sheep Ranch Water Company, is pictured in front of his house in the mid-1880s. (Courtesy of the Calaveras County Historical Society.)

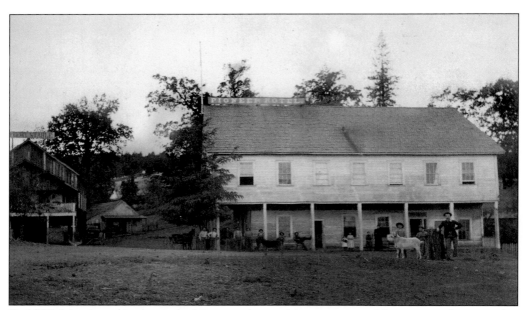

By 1887, Mauritson/Anderson had improved upon his enterprise, adding a second story to his building and naming it the Pioneer Hotel, catering to the miners working in the nearby Sheep Ranch and Chevanne mines, providing room and board and alcoholic beverages. His livery stable, with public hall on the second floor, was located across what was then the main road to the mines on San Antonio Ridge (now Fricot City). (Courtesy of the Calaveras County Historical Society.)

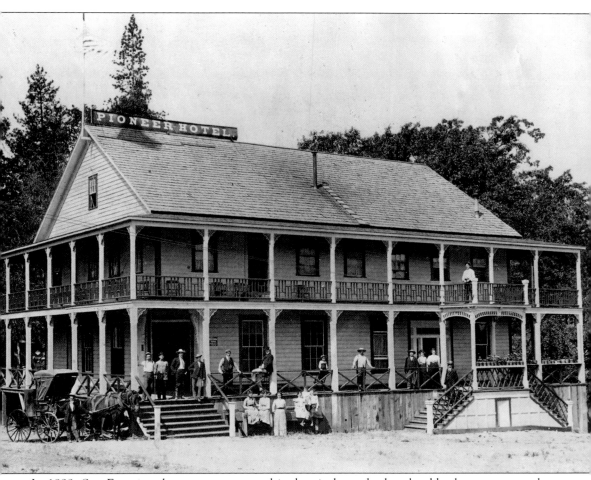

In 1899, San Francisco house movers were hired to jack up the hotel, add a lower story, and build two-story porches on the building. The gentlemen's entrance was located to the left of the building, with the ladies' entrance on the right. The lower floor contained a parlour, ladies' parlour, bar, barbershop, dining room, and kitchen in a separate building. (Courtesy of the Calaveras County Historical Society.)

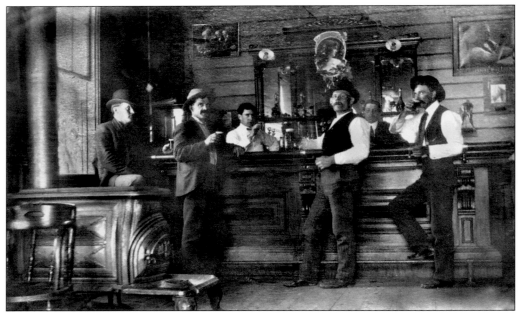

After a hard day's work, saloons and bars were the gathering places for the men of the towns. In this photo, a group of men belly up to the bar at the Eagle Hotel around the turn of the 19th century. (Courtesy of the Calaveras County Historical Society.)

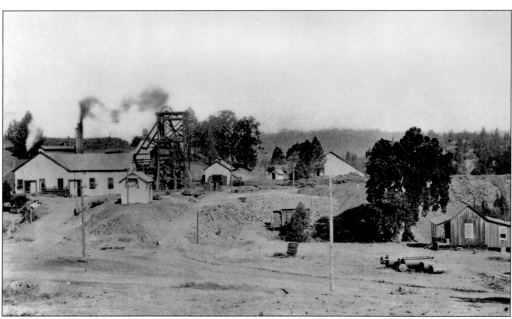

This view of the mine was photographed in the early 1900s, after the Sheep Ranch Mining Company acquired the property in 1898. The company operated the mine until 1907, when it closed again. Depicted are the new mill, clad in corrugated metal, the square set head frame, several ancillary buildings, and the mine office in the right foreground. (Courtesy of Judith Marvin.)

In 1917, the Mona Cali Mines Syndicate took over the mine property and constructed a cyanide mill, far more efficient than the amalgamation systems of the earlier two mills. The large rehabilitation costs left the company short of development funds, however, and the mine again closed for 15 years. The town appears almost deserted in this snow scene taken in the early 1920s. (Courtesy of the author.)

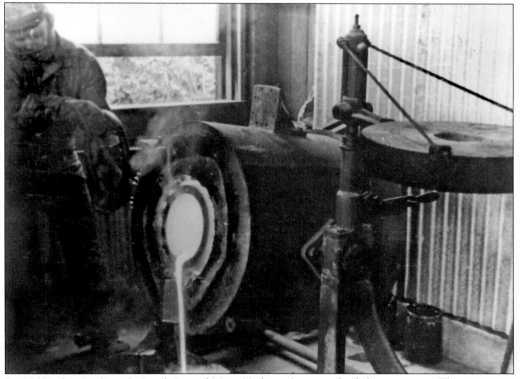

In 1937, the St. Joseph Lead Co. of New York took control of the property. The company dewatered the mine, installed a modern flotation mill, and sank the shaft to a final depth of 3,600 feet. A large amount of gold was recovered during their tenure, some of which is being poured from the furnace into the mould. (Courtesy of the author.)

The town also experienced another boom, as more buildings and residences were erected to house the influx of miners and their families. In this view, taken from the headframe of the mine in 1942, houses for the bookkeeper and another employee are shown in the foreground, with the two-story Poe Hotel in the center, the dance hall to the right, and residences scattered around. The mine closed that year, as the result of War Production Board Limitation Order L-108, which effectively ended gold mining in the Mother Lode. (Courtesy of the Calaveras County Historical Society.)

This last remnant of the 1880s glory years of mining in Sheep Ranch, the cabin of miner O.C. Woods adjoining the Chevanne Quartz Mine, finally collapsed and turned to dust in the early 1970s. (Courtesy of the author.)

Ten

REVIVAL

After slumbering for several decades, Murphys, like many other towns in the California Mother Lode, began to reawaken with the renewed interest engendered by the centennial celebrations held throughout the state in 1948–1950. Books were written, photographs taken, pageants performed, tours conducted, and towns publicized in a way that they hadn't been since the days of the Gold Rush. Ghost towns became popular, and there was a renewed interest in both mining and winegrowing.

Although Murphys developed slowly at first, with a few homes restored and many more demolished, the last decade has been one of unprecedented growth and development. Spurred by the establishment of Stevenot Winery and the others that followed in its wake, the town has now spawned an unprecedented amount of shops, stores, restaurants, inns, and other amenities that rival the days of the '49ers.

Today, dedicated individuals and groups strive to preserve as much of historic Murphys as possible. While they also recognize that some change is inevitable and often desirable, the preservation-minded do not want change to destroy all of the historical ambience of Murphys and Calaveras County.

From its beginning in the Gold Rush through the depressions caused by the 1880s phylloxera epidemic and the decade of Prohibition, the wine industry has persevered in Calaveras County and today is the second most important agricultural industry in the county. Most of the recent vineyard and winery developments have occurred in the Murphys area; these include Stevenot, Chatom, Ironstone, Twisted Oak, Milliare, Black Sheep, Indian Rock, Laraine, Malvadino, Boitano, Irish, Zucca Mountain, Lavender Ridge, Newsome Harlow, Broll Mountain, and Hatcher, all of which produce grapes and bottle wine.

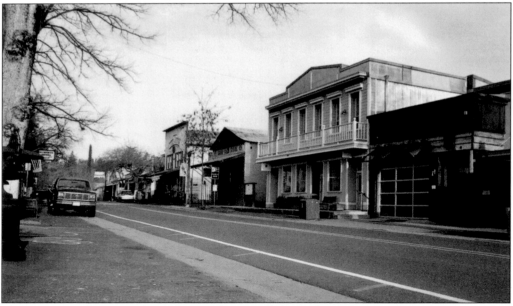

The commercial center of today's Murphys is still focused on Main Street and consists of an interesting mix of historic buildings, recently erected structures in the style of the Gold Rush era, and the very modern.

Although many of the downtown buildings no longer retain their original tenants or uses, they have been restored and have found new lives. The Independent Order of Odd Fellows Hall, constructed in 1902, now houses a commercial enterprise.

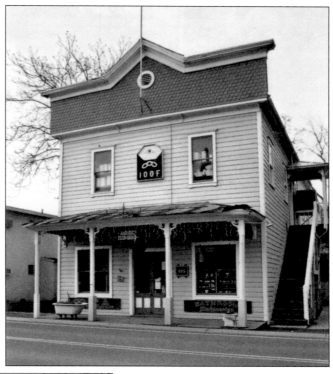

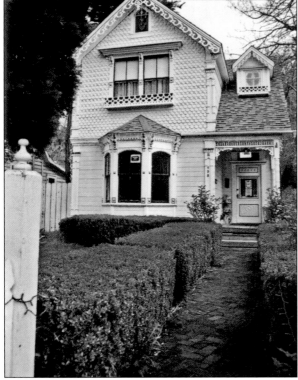

Residences have also been converted to commercial use. The 1899 Thorpe residence now houses the Auberge; other restaurants in town include Grounds, Alchemy, Murphys Grille, Lorenzo's, Firewood, Peppermint Stick, Pick and Shovel, "V," and the original Murphys Hotel, as well as several sandwich shops, bakeries, and smaller eateries.

On warm afternoons and evenings, people gather in Murphys Park to listen to music, picnic, play, and wade in Murphys Creek, which still flows through town as it has for many years.

Although the population of Calaveras County has quintupled in the past 30 years, descendants of early families still reside in Murphys. Here, Barden Stevenot (whose ancestor Gabriel arrived in 1849) pours some of his newly produced and bottled Albarino wine for old friends Mike Dorroh (whose ancestors came to the area in the 1860s and 1870s) and his wife, Fritzi (a descendant of the Cuneo and Costa families from Genoa, who arrived in San Antonio Camp and Calaveritas in the early 1850s).